£7

THE WORKBOOK OF PHOTOGRAPHIC TECHNIQUES

JOHN HEDGECOE

The Workbook of Photographic Techniques

© 1985 Reed International Books Ltd
Text © 1985 Reed International Books Ltd and John Hedgecoe
Photographs © 1978, 1979, 1980, 1982, 1983 and 1984 John Hedgecoe
Edited and designed by Mitchell Beazley, an imprint of Reed Consumer Books Ltd
Michelin House, 81 Fulham Road, London SW3 6RB
and Auckland, Melbourne, Singapore and Toronto
Reprinted 1985, 1986
First Paperback edition 1990, reprinted 1994

ISBN 0 85533 867 9

Editor	Frank Wallis
Associate author	Richard Platt
Consultant art editor	Mel Petersen
Art editor	Zoe Davenport
Production	Jean Rigby
Artist	Kuo Kang Chen

Acknowledgements:72-73, Stephen Dalton/Oxford Scientific Films;
128, Fred Dustin

Typeset and prepared by T&O Graphics and
Taylor Jackson Designs Ltd, Lowestoft, Suffolk
Reproduction by Gilchrist Bros. Ltd, Leeds
Printed in Hong Kong

THE WORKBOOK OF PHOTOGRAPHIC TECHNIQUES

JOHN HEDGECOE

MITCHELL BEAZLEY

CONTENTS

INTRODUCTION

Today's modern cameras, some of which even attend to focusing automatically, have removed from photography much of the technical guesswork that still remained. What they cannot do, however, is the heart of photography. They cannot choose your subject or scene, or decide how to capture it in the most convincing way. They cannot make decisions about what lens or

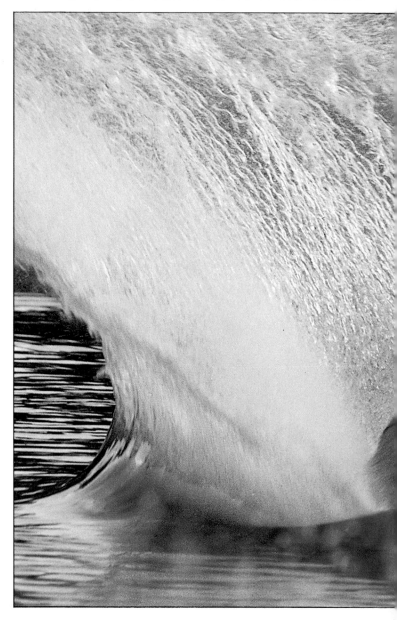

viewpoint to use, how to compose your picture, or how to crop a print. The camera is still only a highly efficient tool; and it needs a craftsman to make proper use of it. This book is about how to do that; about how to use equipment to its best advantage; about how to make the decisions that you alone must make if you want to create not merely good photographs but great ones.

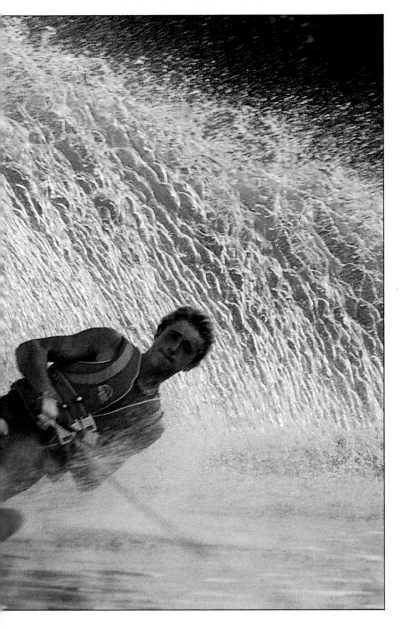

GET THE EXPOSURE RIGHT

Film gives its best only when it receives a precisely regulated amount of light. The shutter speed and aperture controls work together to achieve this — but to set these controls correctly, you must first measure how brightly the subject is lit. Most cameras now do this themselves, but if you understand the principles of exposure, you can get better results, even with an automatic camera.

● **Know your meter.** Most SLR cameras have 'centre-weighted' meters that are influenced more by tonal areas in the middle of the picture than at the edges. This works well if the subject is central in the frame — but less well with off-centre subjects.

● **Meter the most important area.** If the main subject is off-centre in the picture, turn the camera and centre the subject in the frame. Note the exposure reading, then recompose the picture and set the measured exposure manually.

● **Watch for false readings.** All meters assume that the subject is an average grey tone and will give incorrect results with light and dark subjects. With a light subject, you should open up one or two stops more than the meter recommends, and vice versa.

● **Take care in sunlight.** On grey days, careless metering often does not matter, but sunny weather creates greater contrast. Take readings from both dark and light areas, and average them.

● **Use a hand-held meter** with colour slide film. Transparencies need very accurate light measurement and a hand-held

meter can measure the light falling on the subject, a more accurate method than measuring reflected light — as shown below.

● **Bracket exposures.** Take one picture at the indicated exposure, then over- and underexpose by one stop. This ensures that one of the three pictures will be perfectly exposed.

Incident light is the light that falls on the subject rather than that reflected from it. Measuring incident light is a way of increasing exposure accuracy. You need a hand-held meter with a diffuser over the light cell and to get the reading the meter should be pointed at the light source, not at the subject itself.

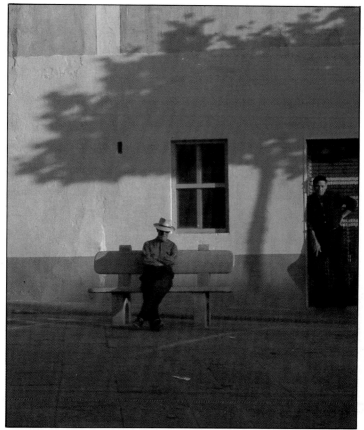

▲ A simple through-the-lens meter reading could easily underexpose the shadows in a scene like this. Correct exposure is midway between a reading for the shadows and one for the highlights; here I used a 50mm lens at 1/50, f11.

▼ Only the aperture was changed to take the sequence below. The first two pictures are too overexposed. At f4, f5.6 and f8 the results are almost acceptable. At f11 slight under-exposure has produced rich colours, but at f16 the picture starts to darken.

BALANCE THE CONTROLS

The camera's shutter speed and aperture do not just affect exposure. The shutter speed controls how movement appears on film, and the size of the aperture dictates how much of the picture will be sharp. So how do you balance the controls against each other for the best result?

● **Think ahead.** Do you want to blur movement? Or would you rather keep it sharp? Is it essential that the whole image is in focus? Or would a blurred foreground improve the composition? Unless you weigh up all these factors, you will not be able to make a reasoned decision about how to set each control.

● **Select shutter speed first** when you want to control the appearance of movement, as I did with the skier on the opposite page. Shutter priority cameras allow you to do this anyway, and then set the correct aperture for you. With aperture priority cameras you should adjust the aperture while watching the signals in the viewfinder. Closing down the aperture will force the camera to select a slower shutter speed, thereby blurring motion.

● **Select aperture first** when you want to control depth of field. Wide apertures (low *f* numbers on the aperture ring) keep less of the subject sharp (see page 15). Small apertures (large *f* numbers) give greater depth of field. With a shutter priority camera, watch the readout in the viewfinder while

you adjust the shutter speed; you'll see a wider aperture indicated as you set a faster shutter speed, and a smaller aperture with a slower speed.

▼ Varying the controls changed the picture of the stream, which was 'frozen' at 1/250, *f*4 (left). A slow speed blurred the water but allowed a small aperture that kept foreground twigs sharp.

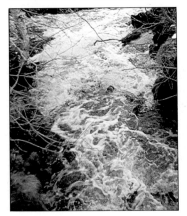

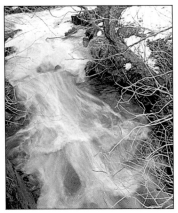

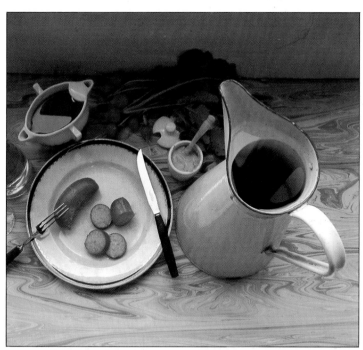

▲ Aperture was the important control in the still life — with the camera on a tripod, I was able to expose for 1 second and use *f*22 for maximum sharpness.

▼ Shutter speed had priority in the skiing picture: I selected 1/30 to deliberately blur movement. This also allowed a small aperture (*f*16) to keep the picture sharp.

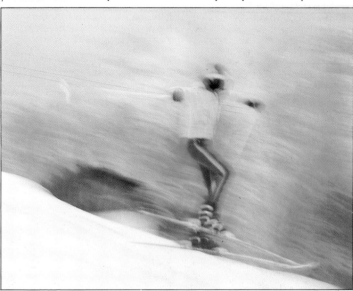

USE EXPOSURE LATITUDE

Exposure errors are not always disastrous — you can sometimes compensate when making a print from the slide or negative. However, while slides tolerate a little underexposure, negative film is more tolerant to overexposure.

● **Use colour negative film** or black-and-white film — they have wide exposure latitude, which means you don't have to spend too much time worrying about the accuracy of your meter.

● **Overexpose negative films** if you are unsure about the correct setting. With colour negative film and dye-image black-and-white film, overexposure actually has the effect of reducing grain size.

● **Colour transparency film** has very little exposure latitude. If anything, underexpose, because colours will be strengthened. You can rescue underexposed slides in printing.

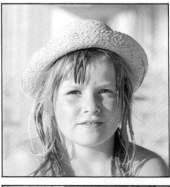

▼ The larger picture was exposed for the shadows. For a more intense mood (below) I chose 1/500, ƒ8 — between the 1/2000 reading for the sun and 1/60 for the darkest area of sky.

▲ Exposure for the girl's skin (1/125, ƒ8), captured the sunny atmosphere. I then closed down to ƒ11 to strengthen colours and increase sharpness and contrast.

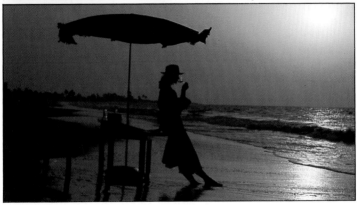

VARY EXPOSURE FOR TONE

The exposure setting that your meter indicates is simply a guideline rather than a never-to-be-broken rule. Often deliberate over- or underexposure will give equally good or even better results than if you slavishly follow the meter reading.

● **Use slide film** when aiming for precise control of tones. The laboratories that print colour negatives always compensate automatically for over- or underexposure, thus masking deliberate exposure changes that you might have made.

● **Overexpose for high-key.** Extra exposure will lighten and 'clean up' skin tones in a portrait, or suggest heat and brilliant sunlight in a landscape photograph.

● **Underexpose for low-key.** Tones will be darkened and colours will look richer. Outdoors, slight underexposure for sombre mood can conjure up a storm even on a pleasant day and make rainy weather look like a thunderstorm.

▼ In this sudden summer storm I exposed for the highlights to emphasize dark areas of the sky and lend a low-key atmosphere to the scene. Underexposed photographs are generally more acceptable than overexposed.

▲ Striking portraits can be obtained by deliberate overexposure. It works best with subjects having dark hair and eyes, and dark lipstick. This shot was overexposed by five stops for a romantic 'vignette' effect. Experiment by taking three or more pictures with progressively more exposure.

FOCUS ACCURATELY

If you are using a shutter speed fast enough to rule out camera shake, or to freeze a moving subject, and your pictures still aren't sharp, then (assuming the lens is in good condition) it is almost certain that your focusing isn't accurate.

● **Be decisive.** Turn the focusing ring quickly past the point of sharp focus, then back again until the picture is sharp. Then stop — and take the picture.

● **Move the camera to focus** when taking close-ups. Depth of field is very shallow at short distances, and the quickest way to focus a hand-held camera is to move gently in and out. As soon as the subject is sharp, press the shutter release.

● **Change focusing screens.** If your camera has interchangeable screens, try a different one. A split-image one may help (right). Some screens are optimized for long or short focal lengths.

● **Have a sight test!** Over half of all adults have defective vision, so glasses or contact lenses may well improve your pictures. You can fit a correction lens to the viewfinder window of your camera.

▲ Split-image SLR rangefinder shows the image displaced when out of focus. Many SLRs combine split-image focus with microprisms.

▼ To focus on the legs of this girl on a beach, I knelt down, focused approximately and leaned slowly forward to get the exact focus.

EXPLOIT DEPTH OF FIELD

Control of how much of the picture is sharp is one of the most valuable of photographic techniques: it enables you to draw attention to just one small part of a scene, or else to record every detail of the subject with equal fidelity.

To expand depth of field for overall clarity:

● **Stop down the lens.** Small apertures give more depth of field.

● **Use a wide-angle lens.** The shorter the focal length, the more will be sharp.

● **Focus midway** between near and far points of the scene, then stop the lens down.

To reduce depth of field and concentrate attention on either the foreground or background:

● **Use the widest aperture.** In brilliant sunlight you may have to use slow film (or a dark grey neutral density filter) to avoid overexposure when doing this.

● **Move closer in.** At short camera to subject distances depth of field is reduced.

▲ The eye can skip from the sharply focused ears of wheat to the distant trees thanks to a wide-angle (35mm) lens and an aperture of $f22$.

▼ The boy in the foreground dominates this picture — background detail and colour have been subdued by opening up to $f5.6$.

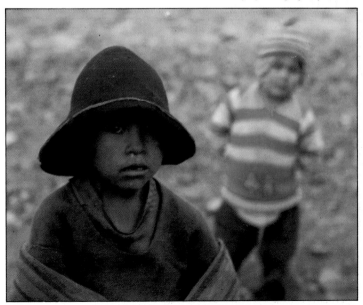

SELECT THE LENS YOU NEED

A normal lens produces the most natural-looking pictures, recording the subject much as we see it with our eyes. But by changing the lens of your camera you can take a fresh look at the subject — either closing in with a telephoto lens to isolate a small detail, or broadening the view with a wide-angle lens to show the subject in its environment.

● **Use a wide-angle lens** for interiors, landscapes and to add drama to mundane subjects. Wide-angle lenses make nearby subjects look bigger and shrink distant ones, exaggerating perspective. Depth of field is greater with shorter focal lengths.

● **Choose telephotos** to magnify the subject — for wildlife, sports, candid shots of children or people at work, and unself-conscious portraits. Telephotos can seem to compress perspective, bringing together subjects that are actually far apart.

With wide-angle lenses, focusing becomes less critical, because the depth of field is so extensive.

Normal lenses (generally 50mm) offer wide maximum apertures, which can be useful in low light.

A long-focus lens brings distant subjects closer. But longer lenses have shallow depth of field.

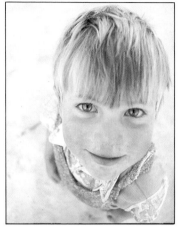

▲ The distortion in this adult's-eye view of a child has helped create an arresting image, the eyes at the centre point providing a direct contact that offsets the exaggeration of the head. Choose the angle of view carefully and, for close-ups, limit the lens to a medium wide-angle; ultra-wide lenses give unacceptable distortion. Here I used a 28mm lens.

▶ A normal lens and a child's-eye viewpoint give a natural-looking result.

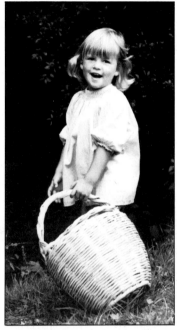

▼ A 135mm lens enabled me to fill the frame to capture the child's facial expression and yet stay far enough away not to inhibit him. Use the 135mm outdoors; a lens between 85mm and 105mm indoors.

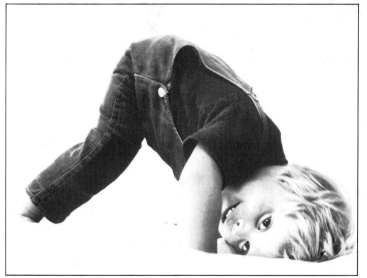

PICK APPROPRIATE FILM

The range of films on the market reflects the fact that different types suit different tasks. There are colour films, black and white films, and slow, medium and fast films. Which you choose depends on the lighting conditions and the results you want.

● **Choose negative film** for snapshots. Colour prints are easy to look at and hand around, and negative film is very forgiving of exposure errors — so it works well in simple cameras. Repeat prints from negatives are cheap and easy to order.

● **Takes slides for quality.** Colour transparency film gives better definition and finer grain — and doesn't fade as quickly as negative film. In the home

darkroom, it's easier to print from a slide than a negative. However, colours may be brasher, as in the example below.

● **Use fast film** in dim light and when you need to use a fast shutter speed or a small aperture — or both. However, fast film (ISO 400 to 1600) cannot match the richness of colour and fineness of detail of slow film such as ISO 64 or 100. Medium speed (ISO 200) offers a good compromise.

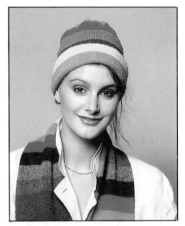

▲ The Cibachrome print from a slide (above) gives a vibrant result, but with some loss of colour accuracy (compare it with the Kodak print from a negative, above left). The dyes used by different manufacturers give different results, suitable for different conditions.

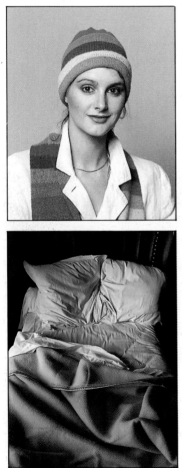

◄ A slow film (Kodachrome 25) and slight underexposure (1/30, ƒ8) produced the rich colours and fine detail of this close-up.

REMEMBER BLACK-AND-WHITE

Black and white film can give scenes a look of gritty realism or graphic beauty. But apart from such aesthetic considerations, it is also more flexible than colour.

▲ For overall sharpness and fine detail choose a fine grain film.

▼ The long exposure needed for this dark scene burnt out the highlights, while the grain of the film suggests the dust-laden atmosphere.

● **Forget filtration** when using black and white film indoors. The colour casts that upset colour films in artificial light and daylight are irrelevant with black and white.

● **Process and print** quickly and simply in a home darkroom. Black and white processing needs only two or three solutions, and processing temperatures are low.

● **Increase development** if you are in dim light and need to increase the speed of the film in your camera. To double film speed (eg from ISO 400 to 800) lengthen development by 30%.

● **Control contrast** during development. With flat lighting, extend development time by about 15-20%. Bright sunlight creates high contrast, so cut development by an equal amount. To prevent thin pale negatives when cutting development, overexpose by half a stop.

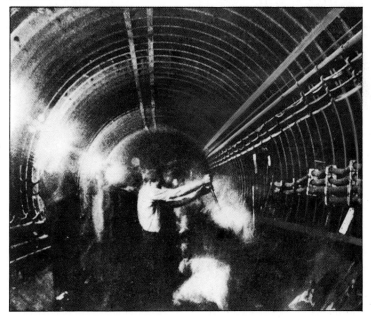

TAKE A RELAXED PORTRAIT

People are among a photographer's most important subjects. The 24 pages that follow offer suggestions for handling everything from a formal portrait through a celebration such as a wedding to the candid picture snatched on a city street. The first thing to learn is how to get your subject to relax.

● **Eliminate fixed grins** by asking sitters to breathe in deeply, puff out their cheeks and exhale through pursed lips. This always provokes spontaneous, natural laughter, which you can catch on film.

● **Cure glazed looks** by getting subjects to look down and close their eyes. On the command 'Now!' they look up at the camera, with a fresh and open expression — and you press the shutter release.

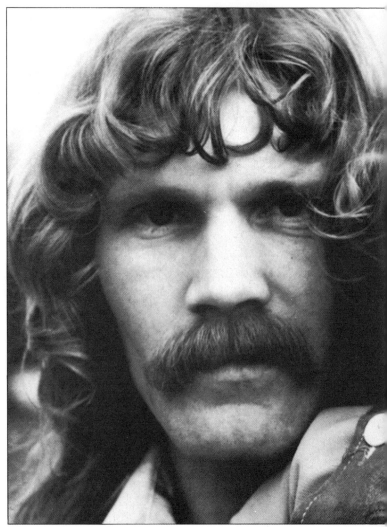

● **Give them something to do.**
'What can I do with my hands?' is the portrait sitter's lament. Most people will adopt a more relaxed pose if they have something to lean against, or a prop to hold.

● **Shoot a double portrait.** In pairs, people have each other to think about and find it easier to ignore the camera. If you want just one of the pair in the picture, you can space them a few feet apart and crop the print.

● **Use a telephoto lens** (in the range 85mm to 135mm) so that you can stand a little way off from your subject. Long lenses are more flattering, too.

▼ I used a zoom lens at 200mm to fill the frame with this father and child portrait while keeping at a reasonable distance. A lens with a long focal length will lose background detail and focus attention on the subject. It is also more flattering to the subject.

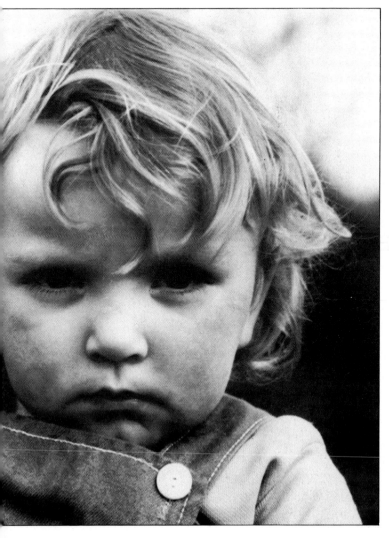

SUGGEST CHARACTER

Traditionally, portrait photographers have tried to flatter by concealing the effects that time has had on the faces of their sitters. By taking the opposite approach — and suggesting visually the subject's experience of life — you can say much more. However, this does not mean photographing people at their worst. Be sympathetic, aim for an honest — but kind — view, and you'll not only get a better picture, but you'll please your subject.

● **Crop in tightly** so that your subject's face fills the frame. By minimizing the surrounding distractions you direct the viewer's eyes to the most important thing: the sitter's face.

● **Use oblique lighting** to reveal the expressive topography of your sitter's features. Soft, non-directional lighting smooths out the wrinkles that make every face unique.

● **Keep a subject talking.** Most people have characteristic gestures that, used in relaxed conversation, help to reveal their personalities.

▼ Black and white film captures the character-revealing texture and fine detail of an old man's face; colour film the unshaven beard and beads of sweat that confirm the physical nature of a boxer's professional life.

▼ The elegance of Erte, the French designer, is summed up by light reflected from his monocle.

▶ Ebbing light at dusk and a low tide create an appropriate and natural background for an old Indonesian fisherwoman.

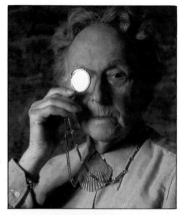

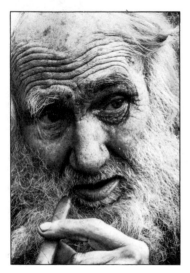

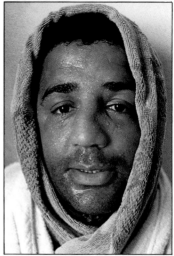

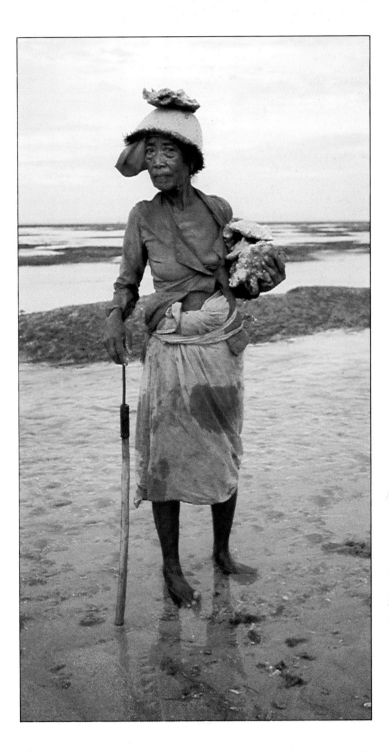

CREATE A SILHOUETTE

Present an original view of your subject by using backlighting. By controlling exposure carefully, you can create a solid black mass in which the shape is the key to recognition, or else opt to reveal just a hint of detail.

● **Choose a background** that is light in tone — a dark background merges with the subject.

● **Pick a bold shape.**
Profiles work well in silhouette, but full-face portraits do not.

● **Meter the background** and overexpose by two stops, or . . .

● **. . . Meter the subject** and underexpose by two stops.

● **Avoid colour prints** because, unless given special instructions, the processing laboratory will 'compensate' and spoil the silhouette

● **Boost contrast** by printing black and white film on hard paper or by pushing slide film.

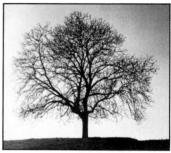

▲ Gradations of tone and detail possible in silhouettes can range from dramatic outlines with almost no detail, such as that of the tree above, through high contrast with slight detail (below) to low contrast pictures (opposite) in which there is considerable detail in the background and only the main subject is silhouetted.

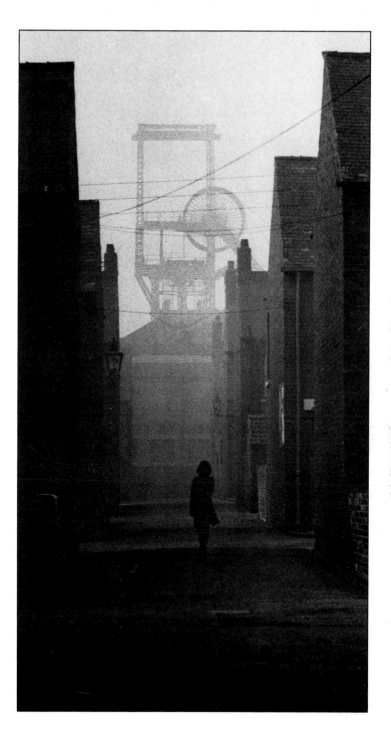

WATCH THE BACKGROUND

The background is a living part of any portrait. It can set the scene, play a role, or simply provide an empty stage. A plain backdrop that frees you from distractions enables you to concentrate upon revealing the personality of your subject.

● **Use the stop-down button.** Unsightly backgrounds, often invisible when focusing an SLR, sometimes look much sharper in the final picture. Use the stop-down control to check how clear the background will be.

● **Light the background** and subject separately in a studio so that you can advance the sitter by adjusting the lights. Achieve separation by making the background one to two stops brighter or darker than the subject.

● **Set a wide aperture** to tidy up a cluttered background. The shallow depth of field that results will hide unsightly details. Take this trick a step further by using a telephoto lens. In bright sunlight, and with fast film, use a neutral density filter.

● **Set the scene** by choosing locations that reflect the interests or working environment of the sitter (below right). A wide-angle lens will take in a glimpse of possessions.

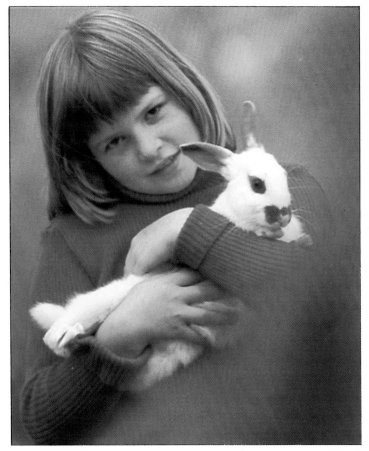

▲ A patterned background helps the impact of this portrait, in which tone, colour and shape are already strong elements.

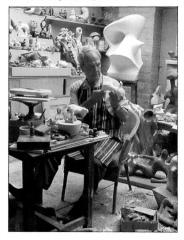

◄ A 400mm lens, at 10 metres, blurred foliage into a green backdrop. Sculptor Henry Moore was taken at work (right) and American graffiti lent design to the street portrait above.

TAKE A SELF-PORTRAIT

Taking self-portraits can be demanding; but being both subject and photographer is also exciting. You get the opportunity to try out techniques and lighting effects to an extent that might demand too much patience from a professional model.

● **Place a marker** where you intend to stand or sit.

● **Devise** some way of indicating where your head will be. A propped-up cushion will do. Focus and compose on this.

● **Release the shutter** using the camera's self-timer, a long cable (or air) release, or the remote release of a motor-driven camera. If your hand appears in the picture, press an air release with your foot.

● **Use a mirror** to photograph your reflection. This is easier with a waist-level finder than with an eye-level finder. Remember to reverse the negative when you make the print.

● **Experiment.** Try fitting a wide-angle lens and pointing the camera at your face from arm's length.

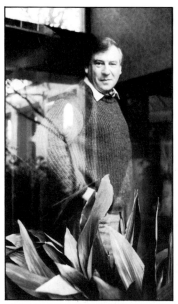

▲ I took this self-portrait by mounting the camera on a tripod outside the window, setting the self-timer, and then moving quickly inside to adopt the pose.

▼ The shadow of the camera was concealed by my shadow in this silhouette self-portrait.

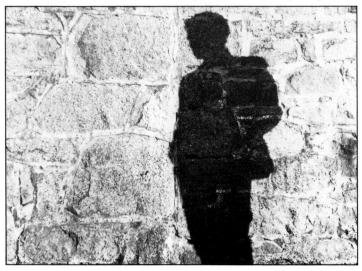

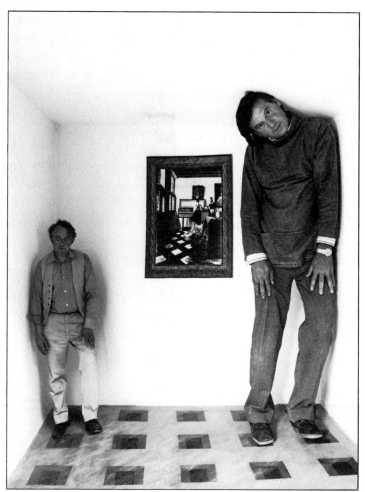

▲ This self-portrait called for the construction of a special prop, known as an Ames room after the American painter who devised it. Needless to say, both of us in the picture are of normal height — it is the room that is not normal. The original idea of the room was to show how our memories condition us to jump to conclusions — in this instance that the room is rectangular with its walls and floor at right angles. In fact, it is distorted: the rear wall is almost 14 feet high and the point where I am standing only about five feet high. From one particular point — at which I set up my camera — the perspective appears normal: except that the eye refuses to believe the disparity between the two figures. The fact that the room is being seen through a standard lens helps the illusion: from the same view-point the human eye, with its greater angle of view, would receive sufficient information to enable a viewer to understand that the whole effect was an optical illusion. The camera, which at least is faithful in recording what it sees, does offer some clues: for example, the angles of our feet, the slight sideways tilt given to our stances and the crooked painting.

29

SOFTEN THE MOOD

The camera records what its lens sees — which is not necessarily what the eye sees. As a result, halcyon days and romantic summer afternoons are sometimes less idyllic on film than they are in memory. To recapture the mood, nature may have to be helped.

● **Add soft focus,** either with a soft-focus filter or with a home-made substitute. Try smearing petroleum jelly onto a skylight filter (not onto the lens itself) or stretching a piece of clear plastic over a lens hood.

● **Use black and white film.** Black and white images of péople and places suggest the days before colour film was widely used, days when family snapshots faded in dog-eared albums.

● **Tint the image sepia.** With colour film, fit a sepia filter — a Wratten 81 EF is a good choice. Black and white prints, even those produced by commercial laboratories, can be toned, in daylight, with kits sold by most photographic shops.

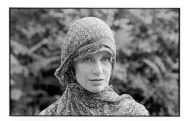

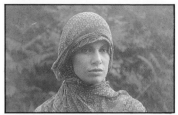

▲ Soft-focus filters diffuse the image, creating a halo of light around the subject.

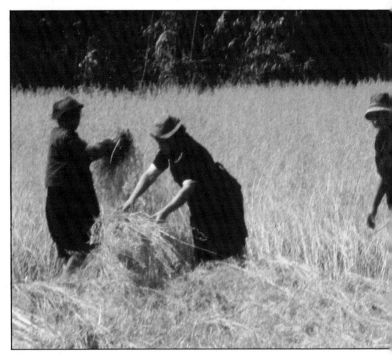

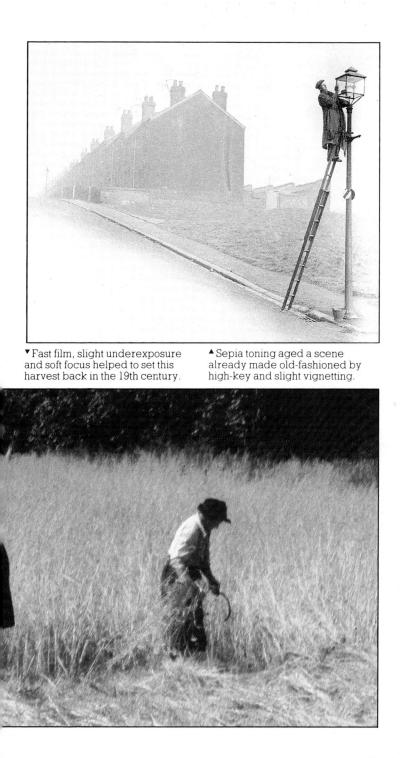

▼ Fast film, slight underexposure and soft focus helped to set this harvest back in the 19th century.

▲ Sepia toning aged a scene already made old-fashioned by high-key and slight vignetting.

CAPTURE GROUP IDENTITY

Large groups of people can be difficult to photograph — if you take too casual an approach to your subjects, there is a danger that your picture will show them as individuals and that the feature that unifies everyone will not be clear. Careful grouping and a well-chosen location can help you to avoid this.

● **Use chairs and stairs** to elevate some members of the group: if everyone's head is at the same height, the composition lacks variety and interest.

● **Sit some of them down.** This too will add variety and interest to the shape of the group.

● **Get their attention** by blowing a whistle just before taking the photograph. In big groups everyone talks and looks away from the camera until a trick like this makes them stare at it.

● **Take lots of pictures.** The more people in a group, the greater the chance that someone's eyes will be closed when the shutter is open. Extra pictures are an insurance policy.

● **Move people together.** The camera makes people appear farther apart than they were. To create unity and form, position them tightly together.

● **Respect hierarchy.** Most groups have a leader and a formal structure. If it exists, your picture will be stronger for emphasizing it.

● **Make them work.** When everyone pulls together (as in the picture below) their common interest is obvious.

● **Be prepared** to take candid pictures as the group breaks up. Informal groups — or departing wedding guests, for instance — often express the spirit of the occasion best.

▼A wide-angle lens catches the different expressions as a team of girls defeats a boys' team in a friendly and untutored tug-of-war. The lens let me get in close enough to include the whole team with good overall sharpness.

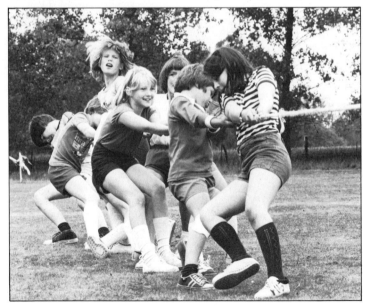

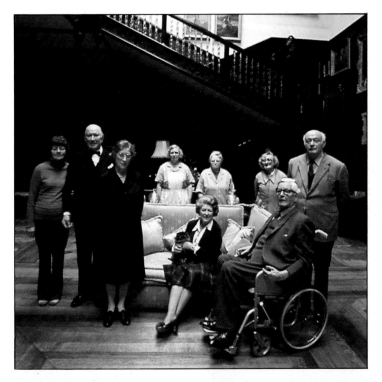

▲ Surroundings are important in a group portrait. Here they confirm the lifestyle suggested by the central arrangement.

▼ These girls arranged themselves into a visually satisfying group without any prompting from me. I used a 28mm lens.

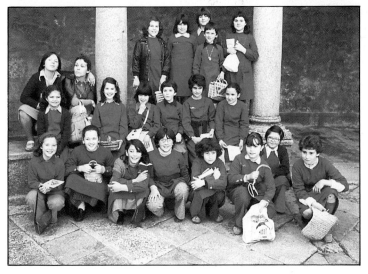

CATCH THE GOOD TIMES

If you can keep your head while all around you are losing theirs . . . you're not having a good time. But unless you do, party pictures are likely to display the rawest of faults: out-of-focus blur, decapitated trunks, sloping verticals. Be aware of the problems, however, and you can plan to avoid them.

● **Use a 35mm** snapshot camera. These do everything — including focusing — for you, leaving you free to talk to your friends and enjoy yourself.

● **Use a wide-angle lens** on an SLR. It will reduce the need for accurate focusing and will let you get a reasonably broad view, even at a crowded party.

● **Don't forget** the formal views. At weddings and similar functions there are some pictures that simply must be taken — such as the bride and groom on the church steps. If you're the only photographer, and you miss these, you won't be invited to the christening.

● **Watch** for 'grab shots'. People let their hair down at celebrations, so there'll be ample opportunity for some revealing insights into character. For tips on this, see pages 40-41.

● **Use an auto flash.** Juggling guide numbers slows you down: with auto flash you need never move the aperture ring.

● **Change flash batteries** before you start taking pictures or you'll be forever waiting for the ready light to come on.

● **Move close** in smoky rooms. Smoke cuts contrast, dilutes colours and reflects light from a flash.

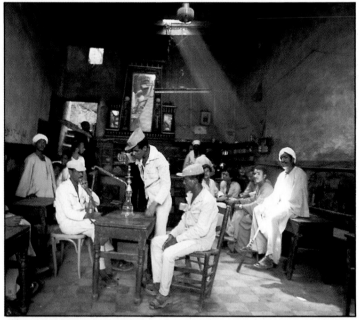

▲ Preparations for a convivial gathering in an Egyptian cafe are caught by a wide-angle lens, which even at f3.5 gives good depth of field (and covers the whole room). The shaft of sunlight illustrates how smoke can obscure detail in a picture taken in close conditions.

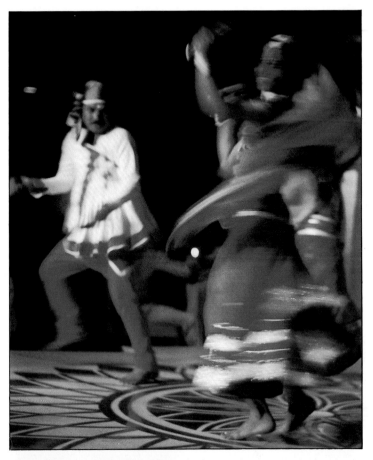

▲ I wanted movement in the picture of Bombay dancers, so shot at 1/15, but used 1/250 to catch the pose of the English bridesmaid (left) celebrating after a wedding. The same wedding produced the informal shot below of a formal occasion — reading the telegrams.

RECORD THE ZEST OF YOUTH

Children are marvellous subjects — spontaneous, energetic, un-inhibited and expressive. They are best photographed when they are engrossed in some activity, but a record of their progress from birth to adolescence should include a few more formal portraits taken at important milestones.

● **Vary the angle of view.**
Pointing down with an SLR at eye level can produce attractive pictures, like that opposite, but crouching, sitting or lying lets you compose more flexibly.

● **Give children time** to forget your presence. They have short attention spans and will soon lose any self-consciousness. A telephoto lens will get you away from the immediate vicinity.

● **Use a wide aperture** and a fast shutter speed when you want to freeze rapid movement and soften the background and . . .

● **. . . Use a small aperture** and a slow shutter speed when you want to show movement through blur against a sharp background.

● **Pre-set the camera,** and load fast film, when you are uncertain what will happen.

● **Photograph babies** in warm, calm and familiar surroundings with the mother close at hand.

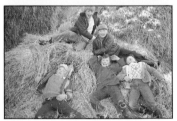

▼ Changing viewpoint changes the picture. The boys below were shepherded into a conventional arrangement for an eye-level portrait, but then allowed to choose their own grouping for the low- and high-level shots above. They were then free to express their personalities.

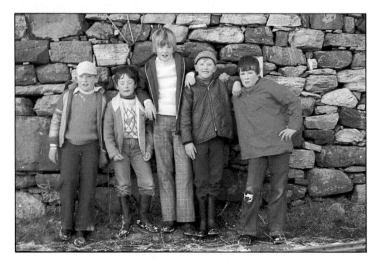

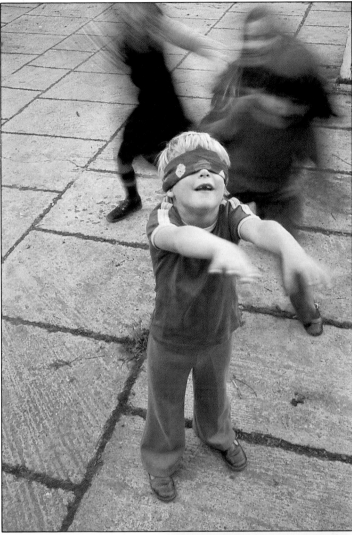

▲ I braced myself against a wall to take the game of blindman's bluff at 1/15 and an aperture of $f16$, using a 35mm lens to cover the whirling figures. The baby, taken in soft, diffused sunlight, called for high-speed film and an exposure of 1/30 at $f8$.

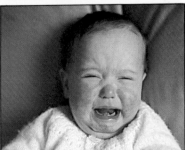

ABSTRACT THE NUDE

To gain the experience needed to cope with the formidable difficulties of photographing the human body, begin with the abstract. Lessons learned about form, tone and texture will stand you in good stead when you come to advanced full figure work.

● **Choose the light** that best creates the mood you are seeking. Side lighting divides the body into dramatic areas of light and shade, and emphasizes form.

● **Frame tightly** to focus attention on just one area of the body.

● **Avoid depicting** the face, which, by suggesting personality and character, leads away from the abstract.

● **Stop down** to increase depth of field. Unsharp areas are distracting in tightly framed photographs.

● **Emphasize skin texture** with baby oil or cold water.

● **Pick the pose** that keeps muscles tense.

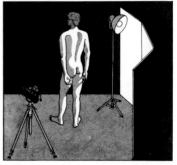

▲ The straightforward technique of bouncing light off a three-sided screen was used to give form to the abstract study below.

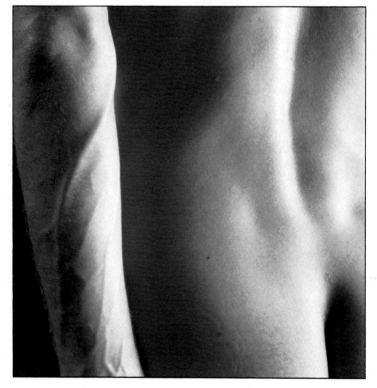

REVEAL THE WORLD OF WORK

The inherent fascination of other people's jobs gives portraits taken in a working environment an extra element that is lacking in the studio. Pose the person fairly close to the camera, but include background detail that identifies the job.

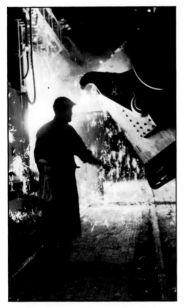

▲ With ISO 200 film, available light served for the picture above; exposure below was based on the floor, an average grey area.

● **Use a wide-angle lens** and stand farther back than you would for a portrait — the background will explain what kind of work is being done.

● **Capture activity.** A portrait of someone working looks better than a static shot of them with the tools of their trade. And if they are working, they will be less conscious of the camera.

● **Seek a viewpoint** that is unusual. The face of the steelworker below is completely hidden, yet the blaze of light behind him clearly expresses the harshness of his working conditions — and hints at the toughness of his character.

● **Take fast film** and flash. The lighting in industrial locations is often inadequate for photography. You may not only have to use fast film, you may have to uprate its speed as well. A small portable flash is useful for lighting figures close to the camera.

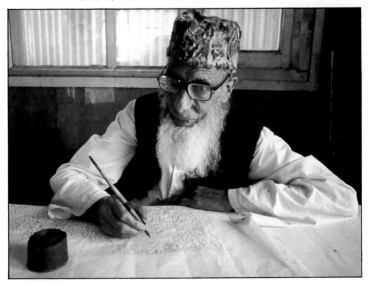

CATCH PEOPLE UNAWARES

By using the techniques of photojournalism you can not only take street scenes that are humorous, intimate or even newsworthy, but also acquire skills that make it easy to create candid, relaxed pictures of your family and your friends.

● **Prefocus the camera** and select a small aperture — a 50mm lens set at 7ft and stopped down to $f16$ will render everything from about 4ft to 21ft acceptably sharp. You can 'point and shoot' without having to focus.

● **Use a wide-angle lens** for pictures like that below right in which you need both depth of field and coverage.

● **Load fast negative film** which allows you to set a small aperture and a fast shutter speed and tolerates exposure errors.

● **Move in close.** Many pictures are spoiled because the main subject is a tiny shape in the middle of the frame.

● **Be decisive.** When you see the picture you want, sight, shoot, and lower the camera again. The subject may not even notice.

● **Don't be content** with one picture. If your subject hasn't noticed you, or seems willing to be photographed again, improve the composition and take more.

● **Teach yourself** to shoot from the hip. A camera held at waist level is far less noticeable than one raised to eye level.

● **Be prepared.** Unless the camera is in your hand, ready, you'll miss the best pictures.

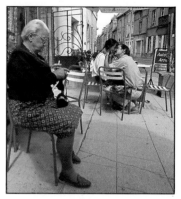

▲ Human interest adds colour. An informal picture of a loving couple, ignored by an elderly woman, captures the flavour of France; below, holiday hats link a mother and her children intent on quenching their thirst.

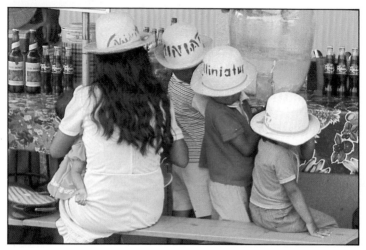

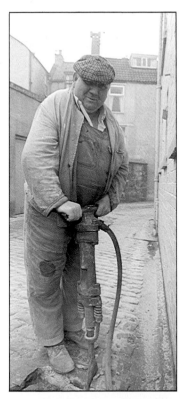

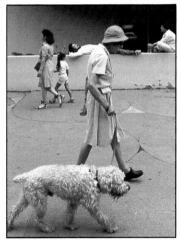

▲ New York's Guggenheim Museum provides a backdrop for a relaxed picture of city dwellers.

◄ A close shot emphasizes the roundness of the drill operator and cuts out irrelevant background.

▼ A wedding group splits up just as a gust of wind ruffles hair, sends a veil flying and almost removes a hat.

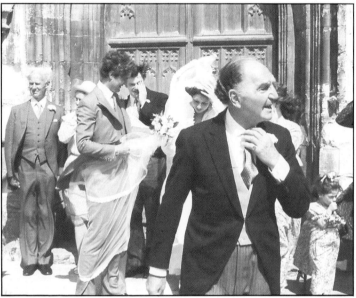

MAKE PHOTOS TELL A STORY

Every picture tells a story, but a single picture lacks an essential element in story-telling: what happened next? A picture sequence enables you to portray a dynamic situation from start to finish, to show triumph and disaster, and to record what was going on around the main subject as the story developed.

● **Plan ahead.** If you know where the action is likely to take place — as I did when shooting the sports day shown here — you can pick the best viewpoints well in advance.

● **Vary the scale,** either by moving closer to, or farther away from, the subject or by using lenses of different focal lengths.

▾ A story built around a sports day begins with a picture of the judges and then captures a close finish. A medium long-focus lens lets you stay out of everyone's way, but gives you the impact of the close-up.

● **Turn the camera** so that not all your pictures are horizontal.

● **Cheat!** If you miss a particularly good moment that you need for your story, ask the participants to repeat it for you.

● **Don't forget the crowd.** Spectators are often as interesting as what they are watching and their expressions — like those of the schoolboys opposite — can offer solid clues to what is happening behind the camera.

● **Plan the presentation** carefully. Vary print size and use a well-composed layout.

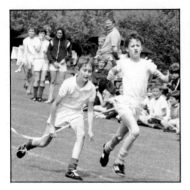

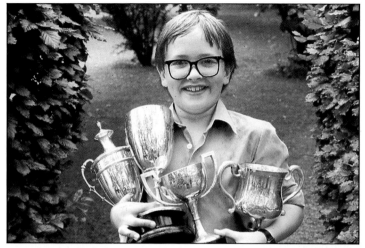

▲ A jubilant smile and an armful of trophies say all that needs to be said about a future Olympic champion's day of glory.

▼ Whatever is going on behind the camera — sprint or tug-of-war — crowd reaction provides a living link in the picture sequence.

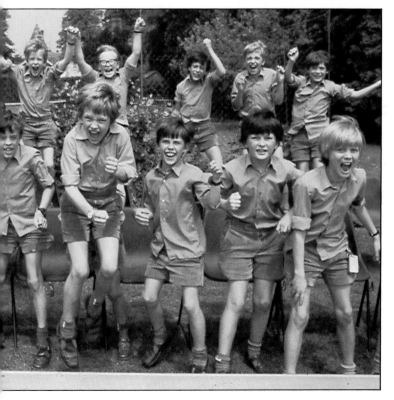

MAKE SHADOWS WORK

Photography is painting with light. The next 30 pages are devoted to light in all its forms, from daylight to stroboscopic light. The section begins by examining the opposite of light — shadow.

● **Use glancing light** early or late in the day to reveal shadows not at their strongest, but at their longest.

● **Watch out** for your own shadow, which may be in the picture if the sun is behind you.

● **Use hard lighting** to make shadows as bold as possible. Outdoors, bright sunlight casts deep shadows. Indoors, use a naked bulb or a small flash unit.

● **Control exposure** carefully. Take meter readings from the brightly-lit areas so that shadows look dark and mysterious.

● **Use slide film** for best results in colour. Negative film has more latitude and thus retains detail, weakening the impact.

▼ Without shadows, the picture below might have proved difficult to 'read' at first glance.

PICK YOUR SUNLIGHT

A studio is a place where the direction of lighting can be controlled. Similar control can be achieved out of doors if you choose the right time of day or vary your viewpoint.

● **Use front lighting** to maximize colour. Colours are at their most brilliant when reflecting the sun.

● **Minimize mist and haze** by standing with the sun to one side. Cross lighting picks out distinct features more efficiently than overhead light or direct frontal light.

● **Add atmosphere** by shooting into the sun. This washes out colours and creates a dynamic picture — particularly when the sun appears in the photograph. Make sure, though, that the lens is clean, because dust and finger-prints will create flare.

● **Make bold shapes** by placing your subject between the sun and the camera. This creates a silhouette with a brilliant halo around it.

● **Suggest heat** by taking pictures at noon — small shadows directly beneath your subjects vividly conjure up the feeling of a hot day.

▼ Patience, determination and perception produce good photo-graphs — and when you are trying for trick shots like the one below, in which the sun looks as if it has just rolled down the side of the pyramid, that means great accuracy in camera angles, focusing and judgement of exposure. I took the picture at dawn, having determined where the sun would rise, and gave an exposure of 1/250 at f11 on ISO64 film. Composition was important — both the sun and the tip of the pyramid fall close to the intersection of thirds (found by dividing the picture with three horizontal and three vertical lines) and the line of the camel rider's back and the haunches of the animal is almost parallel to the edge of the pyramid. Finally, the black foreground creates a solid base on which the whole picture can rest. In a photograph like this colours are deliberately muted, and the elements allowed to become silhouettes, in order to emphasize the composition.

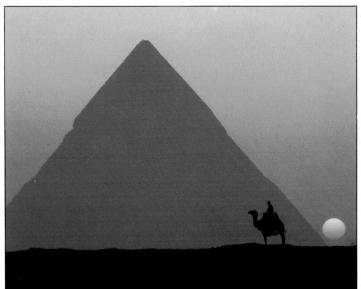

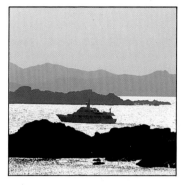

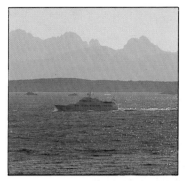

▲ The first in a series of pictures taken over 15 minutes shows the subject backlit by a high sun. A 200mm lens pulls the mountains up, but both they and the yacht are almost totally in shadow. In the next shot, taken as the boat moves away from the sun's path, light creeps round its stern. All shots were exposed for the highlights.

▼ The sun strikes the yacht from the rear in the third shot, modelling its detail. Flag colours and a brown tender can be seen. At this angle the reflected wake gives a strong sense of momentum and the background is sharper. As the yacht moves into sunlight in the fourth picture, it reflects the blue sea.

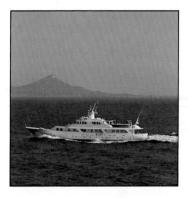

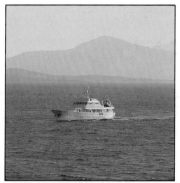

▶ Finally, the yacht has rounded the headland and has moved into full sun. Direct light has made the sea a brilliant blue, but the yacht looks flat. The tender can now be seen to be red, not brown.

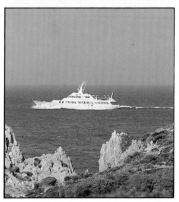

USE LIGHT TO REVEAL FORM

The camera turns three-dimensional reality into a two-dimensional print or slide — it cannot reproduce solidity and depth, but it can suggest them effectively if the subject is properly lit. The key is to avoid direct frontal light.

● **Use side lighting,** which creates shadows that in turn create the modelling needed to suggest form.

● **Soften the light** either by bouncing it from a white surface or by diffusing it with a sheet of tracing paper or cloth.

● **Turn the subject** so that its most characteristic surface is presented to the camera.

● **Soften the shadows** by using reflectors or fill-in lamps.

▼ Patterns of light and shade, cast by sunlight shining through venetian blinds, are a key factor in lending a sense of roundness and depth to the figure.

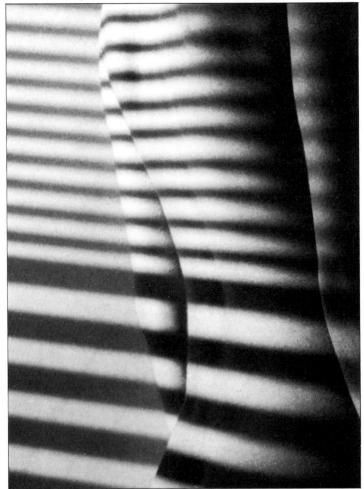

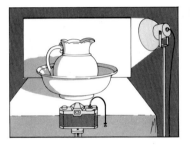

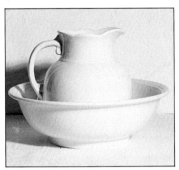
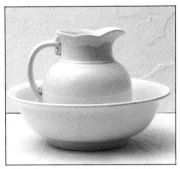

▲ Direct frontal lighting destroyed the form, shape and texture of the jug; undiffused side lighting (below) proved dramatic but too harsh for the subject.

▲ The best result was obtained when light was bounced off a side screen onto both the jug and the background, softening shadows and creating good modelling.

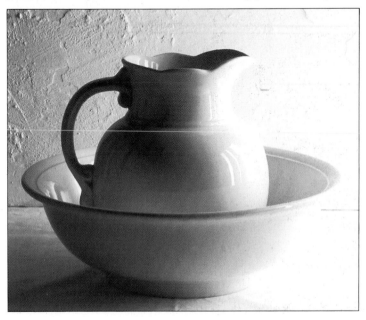

REFLECT THE LIGHT

Strong directional lighting throws deep shadows that can obscure subtle detail. A simple reflector will lighten the shadows and reduce the contrast, creating a more delicate, softer image.

● **Make reflectors from** any white or shiny surface. A newspaper will do, but white card is easier to handle.

● **Use foil or silver card** for directional fill-in light. Crumpled foil scatters light.

● **Use mirrors** for the most brilliant reflection of all.

● **Position a reflector** opposite the main light source.

● **Curve the reflector** to concentrate the light.

▼ A curved reflector, positioned opposite a window, lent such tone and texture to these eggs that they seem almost three-dimensional.

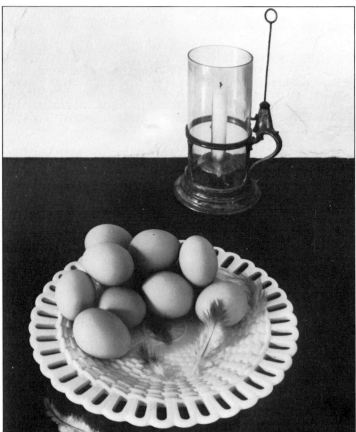

CORRECT COLOUR

When precise colour fidelity is of paramount importance, use correction filters to balance the light falling on the subject to the correct colour temperature of the film.

● **Use 81 series filters** in overcast weather. These pale yellow filters range from 81 (almost colourless) to an 81EF, which is tobacco-coloured. They remove the blue cast from pictures taken in cloudy weather and, in sunny conditions, correct the colour of shaded subjects lit only by blue sky.

● **Use 82 series filters** in the reddish light of dusk. 82, 82A, 82B and 82C filters are pale blue, so they prevent scenes lit by late afternoon sunlight looking too warm in hue.

● **Use two filters** — 80A and an 82B — when taking pictures in domestic light with daylight balanced film. If you have tungsten balanced film in the camera, use an 82B only.

● **Shoot colour negative** film if you don't wish to bother with filtration. All but the heaviest of colour casts can be corrected during printing.

● **Remember** that you can deliberately use colour casts to create unusual colour pictures.

▲ A fluorescent light correcting filter was used above.

▼ An 81C yellow filter was used to counteract a blue cast from an overcast sky.

CREATE ATMOSPHERE

Transparent and translucent subjects are at their most attractive when lit from behind. If the subject is also coloured, backlighting makes hues seem richer and colours more saturated. The technique calls for careful judgement of exposure.

● **Measure exposure** by moving in close to the subject. If you don't, the backlighting will cause you to underexpose.

● **Create contrast** by including both translucent and opaque objects in the picture. In contrast to the clear objects, the opaque will appear as silhouettes.

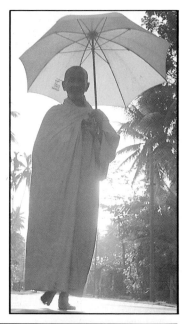

● **Add light** if you want to retain detail in non-transparent objects. Use a small flashgun (see p. 60) or a reflector close to the camera.

● **Use filters** if the subject has no colour. A deep red filter, for example, may add interest to a backlit subject.

▶ The Buddhist monk was taken on ISO64 film with an exposure of 1/250 at ƒ8. Backlit palm leaves show densities of hues (below) that would not have been revealed by reflected light.

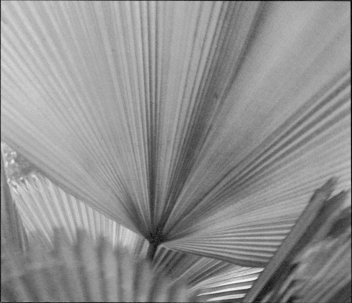

PICK YOUR MOMENT

The colour of natural light changes in the course of the day, varying from the deepest red through white to brilliant blue. By scheduling your photography with this in mind, you can choose the light that suits your subject best.

● **Get up early** to catch the day at its best. Early morning light has an exquisite clarity that is never quite matched later in the day.

● **Shoot at dusk** or dawn to capture the warm sunlight, rich in atmosphere. At the end of the day, when there is still some light in the sky, the street and house lights can add a colourful contrast.

● **Avoid midday.** When the sun is directly overhead, it casts harsh, unflattering shadows straight downwards. This is the worst light for revealing form.

● **Use long lenses early.** Focal lengths longer than 200mm emphasize haze and other atmospheric effects and give best results just after the sun has risen, when the air is cool and clear.

● **Make it quick** at sunrise and sunset. At these times of day, the light changes minute by minute.

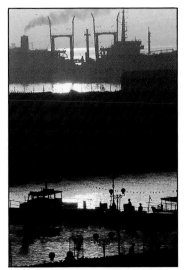

▲ A 200mm lens caught the impressionistic picture of Bombay harbour at sunset. Below, frost, preserved by the bars of a gate, gave substance to shadows.

LIGHT FOR CONTRAST

Hard lighting produces high contrast between the shadows and the highlights of a picture. Use it when you want to create a sense of drama by infusing your pictures with mystery and menace.

● **Use one small light** such as a bare light bulb or a small portable flash.

● **Move the light back.** The farther the light is from the subject, the greater the contrast that will be created.

● **Base exposure** on the highlights to ensure that the shadow areas fill in and create solid black shapes.

● **Block off other lights.**

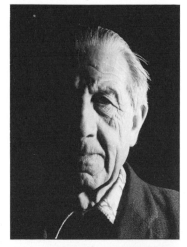

▸ Side-lighting shadowed one side of the face, but left it faintly outlined against the background. Available light produced the contrast in the picture below.

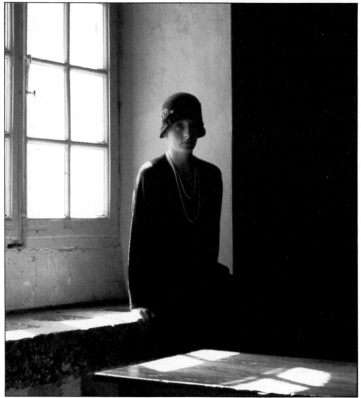

LIGHT FOR DETAIL

Soft directional lighting flatters a subject, revealing fine detail even in shadow and adding warmth and modelling to surfaces. Use it whenever character is important.

● **Use large light sources** such as natural window light or light from an overcast sky.

● **Diffuse the light** of small sources by placing tracing paper or white fabric in front of the reflector, or . . .

● **. . . Reflect light** from a white wall or ceiling. This softens and spreads the beam.

● **Fill in the shadows** by adding extra lights near the camera. Make sure, though, that the multiple light sources don't create multiple shadows.

● **Use reflectors** to fill in shadows, (as explained on p. 51).

▶ Photofloods were bounced off the ceiling to soften the light and eliminate hard shadows.

▼ Casseroled meat was placed on a check cloth chosen for the tone it lent to the subject and lit by a window light and a reflector.

REVEAL TEXTURE

Even heavily textured materials can look flat and dull unless you take steps to bring out the lines and furrows that criss-cross the surfaces of so many natural and man-made objects. Raking light — oblique directional light — is the key to creating texture, but take care with colour film to soften deep shadows or detail will be lost. Landscapes aside, texture is best revealed by moving in close to the subject.

● **Search for texture.** Water, wind and frost etch surfaces in different ways.

● **Choose directional light.** Flat lighting conceals texture.

● **Control colour contrast.** To reveal texture, colour film demands softer lighting than black and white film. Use reflectors or fill-in flash if raking light is very bright.

▸ Architectural detail is revealed by light at 40° and, at ƒ22, half a stop underexposure.

▾ Three hours later than the time at which the first picture was taken, slanting evening sunlight brought out the ruggedness of the Norwegian landscape.

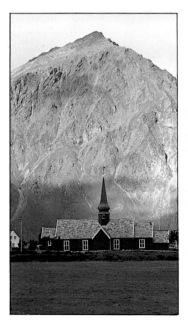

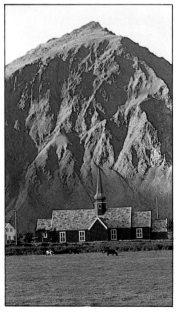

CATCH THE GLEAM OF GLASS

Glass and liquids, though transparent, always have shape: there is always some modelling or some reflections that will produce an image on film. There are problems — but they have several solutions.

● **Use backlighting** to reveal transparency fully.

● **Add colour** to clear glass by adding coloured liquid.

● **Use reflections** to define glassware edges. If a bottle merges with a white background, place black cards on either side of it, just outside the picture. This creates black lines on each side of the bottle.

● **Add bubbles** to liquid by blowing through a straw or by using a syringe.

● **Cope with melting ice** by substituting plastic ice cubes, obtainable from movie prop shops.

● **Use backgrounds** to show the shape of glass. Normal or recognizable backgrounds are best.

▼ Two photofloods bounced off a wall and another placed behind the subject provided backlighting. Paper rolls make convenient plain backgrounds, especially if the colour harmonizes with that of the subject.

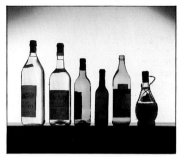

▼ Campari on ice called for a careful balance of lighting and background. The glass was lit by a lightbox, through a hole cut in a grey card placed on the box.

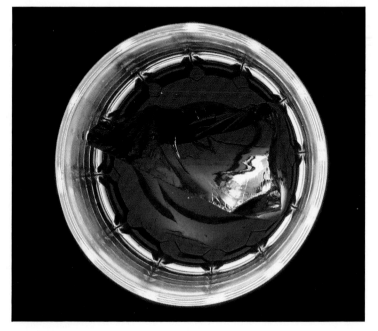

FREEZE WITH FLASH

All but a handful of cameras have top shutter speeds of 1/1000, yet this brief exposure may not be quite short enough to arrest the movement of the fastest moving subject. To stop such rapid action, you should rely not upon the shutter but upon your electronic flashgun.

● **Use an automatic flash,** not a manual gun. Manual flash units emit a pulse of light of fixed duration, whereas an automatic gun produces a variable and usually much shorter pulse.

● **Set the shutter** to the fastest speed that will synchronise with flash, to avoid a 'ghost' image appearing on the film.

● **Choose a wide aperture.** If your flash offers a choice of apertures, select the widest (a low f-number). This ensures that the flash is as short as possible.

● **Move close** to your subject. At near subject distances the flash unit cuts off the pulse of light most rapidly.

● **Bracket your pictures,** because the auto-exposure facility on the flash unit may not be completely reliable when the subject is very close.

● **Take lots of pictures,** because an element of luck is involved. The more pictures you take, the greater your chances of success and the greater the number of variations you will capture.

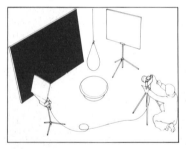

▶ Portable flash giving an exposure time of about 1/1000 was used to freeze the bursting balloon. The flashgun was to one side, angled at 45°, and facing a larger silverized mirror. A slight delay was needed between firing the air pistol and releasing the shutter. A second balloon was used for the third picture.

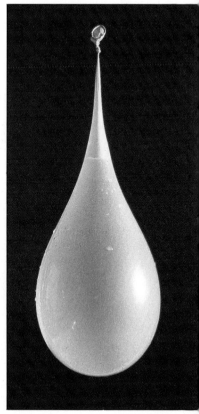

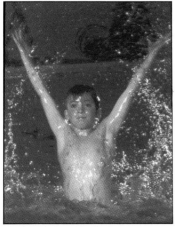

▲ A single portable flash cut out an unwanted background and was fast enough to freeze the spray into individual drops.

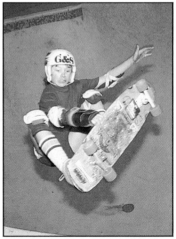

▲ Poor light called for a shutter speed of 1/60 — flash stopped the action with good detail.

MIX FLASH AND DAYLIGHT

Natural light often produces extreme contrast between highlight and shadow — noonday sun, for example, leaves deep pools of darkness in the eye sockets and under the chin. By using electronic flash in daylight as a fill-in light you can reduce contrast and create an image with richer, brighter colours.

● **Use an automatic flash.**
'Fill-in flash' is more difficult with a manual unit.

● **Set the calculator dial** on the flash unit to double the nominal speed (the ASA/ISO rating) of the film in the camera.

● **Pick an aperture** from the options presented on the calculator dial and set this on the camera.

● **Take a meter reading** to find the correct shutter speed.

● **Check** that camera and flash will synchronise at the chosen shutter speed. If not, choose a smaller aperture from the calculator. Then use a correspondingly slower shutter speed.

● **Focus,** then read off the subject distance. If this exceeds the maximum flash distance indicated on the calculator dial, move in closer to your subject.

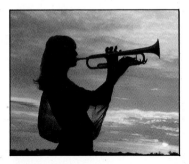

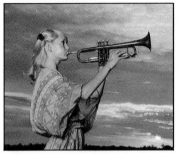

▲ The girl with the trumpet made a striking silhouette posed against an evening sky (top). When the picture was taken again at the same exposure (1/30 at ƒ8), but with fill-in flash added, the result was closer to what the eye would have seen. The sky could have been lightened or darkened by varying the shutter speed.

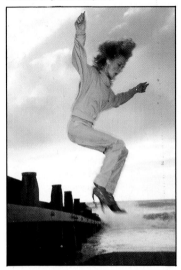

◄ Fill-in flash was used in the picture of a girl jumping down from a pier to bring out detail in the shadows. Without the flash, shooting against the light would have produced a silhouette. The flash rather than a fast shutter speed was responsible for freezing her movement.

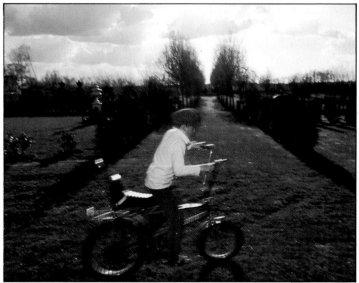

▲ The early morning picture, of a boy riding his bicycle in a country garden, was taken into the light. Fill-in flash brought out detail in the subject and stopped movement just enough to make the picture clear while still leaving sufficient blur to create an impression of speed.

▼ The intense light thrown by the welding torch threw everything around it into heavy shadow, unrelieved by weak daylight from a window. An exposure measured from the torch gave a highlight reading of $f16$, while the reading from daylight on the figure was $f2.8$. After calculating an aperture of $f8$ for flash, I allowed two extra stops for the daylight and the torch (setting the aperture at $f16$) and shot at $1/15$ to record the spark trails. Slight movement effectively softened the image. I used Ektachrome 64 and a 150mm lens.

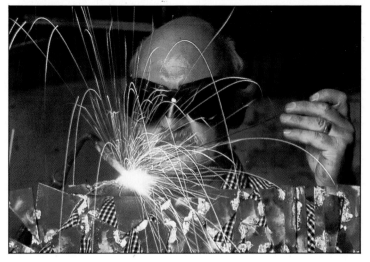

BOUNCE FLASH ACCURATELY

The simplest way to use electronic flash is to lock the unit firmly into the camera's hot shoe and point the flash directly at the subject. But this basic snapshot approach yields flat lighting and unattractive, hard-edged shadows. Bouncing the flash from a ceiling or a wall produces far better results.

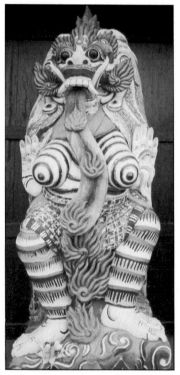

▼ To photograph Allen Jones in his studio, surrounded by examples of his work, I replaced natural light with four flashes, one at 45°, two bounced off the white walls, and one bounced off the ceiling. The result is a close approximation of daylight.

▲ Pattern has a habit of flattening an object, particularly if the picture is taken in soft, shadowless light. To bring out the bright colours and the violent patterns of the fire-breathing Balinese demon, I used a flashgun positioned close to the camera. I diffused its light by bouncing it off a reflector. The intention of the lighting was to bring the statue nearer to the abstract so that the viewer would forget what it was and think of it simply as pattern — a decorative feature. Perfect symmetry or flat lighting tend to strengthen pattern.

● **Use a tilt-head flash,** which has a head that can point upwards while its electronic eye monitors light reflected from the subject. Other flash units will measure light reflected from the ceiling or wall — and thus lead to underexposure.

● **Find a white surface.** Dark or coloured surfaces absorb or tint reflected light.

● **Set a wide aperture —** preferably the widest (lowest f-number) that your flash permits. Bouncing dissipates the energy of the flash much more rapidly than direct flash and if you try to use a small aperture, your pictures are sure to be underexposed.

● **Stay quite close** to your subject to make the best use of the broadly-based flash beam.

● **Carry extra batteries** because the flash unit will be operating at full power for every picture and cells soon run down.

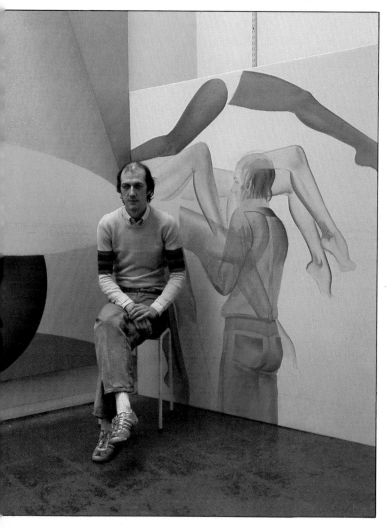

MIX NATURAL AND TUNGSTEN

Colour casts, created by using a colour film wrongly balanced for the light source — for example, daylight film in tungsten light — are usually to be avoided. But what do you do when the light falling on the subject is mixed? Follow a few simple rules and you can use such conditions to create pictures of striking beauty.

● **Let one light source** dominate the picture area. If the sources illuminate equal areas, the picture will look indecisive.

● **Pick film carefully.** Films balanced for daylight or tungsten light will give accurate colour when used appropriately. Use daylight film with a tungsten source and you will get an orange cast; use tungsten film in daylight and you will get a blue cast. Accuracy is not always important: by deliberately breaking the rules, and photographing Dylan Thomas's house below with tungsten film, I created purple tints that made the estuary looking exciting in rather dull light.

● **Use filters.** Light-balancing filters — the yellowish series 81 and the bluish series 82 — can be used in various strengths to exaggerate or to reduce colour casts. An 80A filter turns daylight balanced film into tungsten balanced and an 85 filter converts tungsten film to daylight.

● **Shoot negative film** and adjust colour in the darkroom. Negative film has great tolerance for light of the 'wrong' colour. If you don't like the first print from a negative made in mixed light, you can alter the colours by changing the enlarger filter pack. Fast negative films are most tolerant.

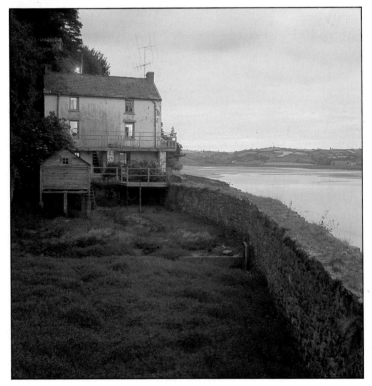

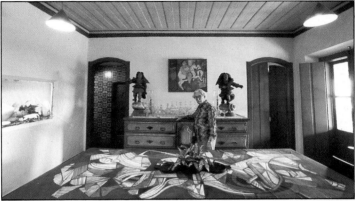

◄ Dylan Thomas's house was photographed at sunset on tungsten film. A mixture of daylight, tungsten lights and bounced flash was used to light the room above: the ceiling lights have acquired an orange glow because daylight film was used.

► For the hotel forecourt either daylight or tungsten film could have been used: I chose tungsten film to bring up the blues.

▼ The richness and warmth of the Ritz dining room has been captured by using daylight film and carefully balancing daylight and artificial light. The daylight film has warmed the light from the tungsten bulbs in the ceiling; on the lefthand side of the room, away from the subdued daylight colours become richer.

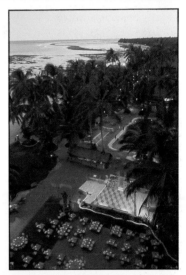

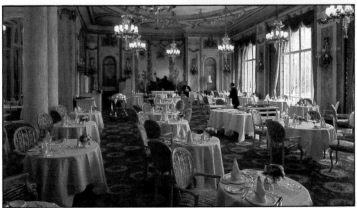

CAPTURE MOVING LIGHTS

In fading daylight, and after dark, the camera can record scenes as the eye never sees them — moving lights make swirling trails of colour on film. Cars especially leave tell-tale traces: continuous bands of white and red from head and tail lights, and broken splashes of amber from directional indicators.

● **Read the instructions** packed with your camera. Some electronic cameras drain their batteries very quickly when the shutter is locked open on 'B'. With these cameras, keep exposures down to 15 seconds or less.

● **Work at dusk or dawn** if you can. At these times there is still a little light in the sky, so your pictures will come out with a brilliant blue backdrop.

● **Use slow film.** Despite the dim conditions, you'll find that slow film gives you a wider choice of exposures. Colours will be richer with slow film, too.

● **Set the camera to 'B',** which holds the shutter open while the shutter release is depressed.

● **Use a cable release.** By locking it you will be able to keep the shutter open as long as you like — without holding the release down with your thumb.

● **Either use a tripod** if you want to record static objects without blur, or . . .

● **. . . Handhold the camera,** as I did for the shot below opposite. This approach makes the whole scene attractively blurred.

● **Guess the exposure.** Take a meter reading first, but don't assume that this will indicate the perfect exposure setting. The sensitivity of film falls in dim light and you should cover a range of exposures if you want to be sure of success.

▼ Daylight film, exposed for 4 mins at ƒ22, caught the head, fog and hazard lights of a Range Rover as it crossed a darkened moor.

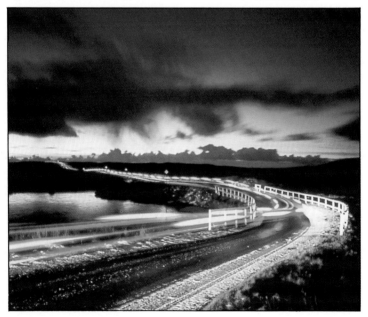

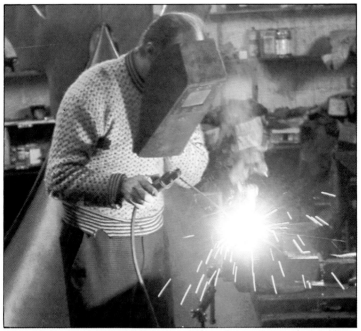

▲ Sparks from a welding torch, shot at 1/30, produce streaks on daylight film, registering yellow as they lose heat.

▼ Neon lights are transformed into a pattern of flowing lines by simply waving the camera about during a two-second exposure at f16.

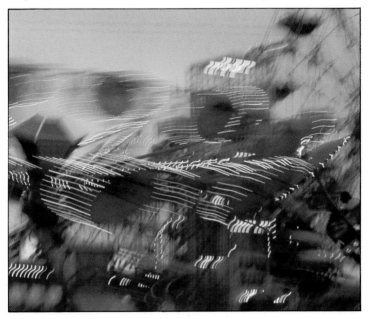

PHOTOGRAPH FLAMES

Fire has an intrinsic fascination that makes it an excellent subject. Today's lenses and emulsions are so fast that you can use flames as a sole source of illumination at night. By day, fire adds excitement or warmth to both indoor and outdoor scenes.

● **Use any film** if flames appear in the picture. Most film is made to give true colours in daylight and pictures taken by firelight always look yellow. But our eyes are accustomed to seeing amber flames, so pictures that include fire look quite natural, even if yellow.

● **Use a filter** if flames light the subject, but do not themselves appear. On daylight film, an 80A filter will retain some of their warmth, but will prevent the colours from looking too heavy.

● **Don't meter the flames** themselves, as they will mislead the exposure meter. Instead, take a reading from the most brightly lit part of the subject.

● **Move the subject closer** to the flames if your meter does not give a high enough reading. Halving the distance between flames and subject quadruples the level of illumination.

● **Use several speeds.** Different speeds can change the appearance of flames dramatically.

▾ A single match provided enough light for the picture below, bringing out warm tones in the girl's face. Candles produce the same effect and are easier to work with. Exposure on ISO160 film was 1/15 at *f*4.

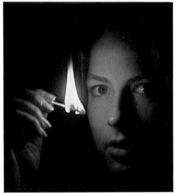

▾ Alertness and an eye for colour will help you to notice the contrasts and contradictions that make pictures like that of the burning stubble more interesting. The shadowy figure of a farm worker provides a clue to the nature of the fire.

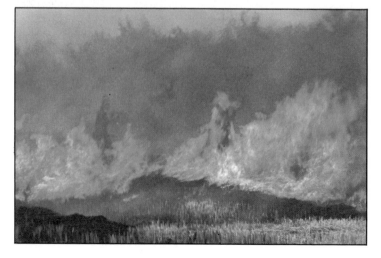

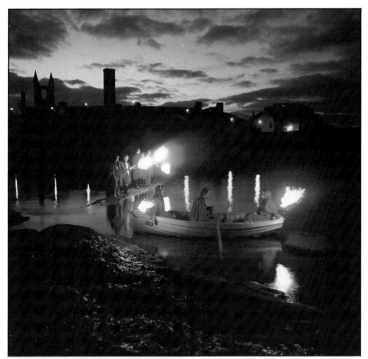

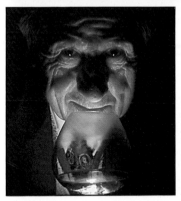

▲ ISO64 film, balanced for daylight, and exposed at 1/2 at ƒ4, emphasized the red robes of Scottish university students.

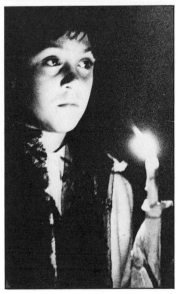

▲ A small torch, shining up through the brandy glass, lit the portrait, with tungsten film giving correct balance to the clothing. Such lighting has to be used carefully or the subject may look sinister.

▶ The girl was lit by a single candle, which created high contrast. The picture was taken on ISO400 film and its coarse grain can be seen in the picture.

CAPTURE FIREWORKS

Fireworks displays, spectacular when you are a spectator, often prove disappointing on film. The reason is simple. As a spectator you are aware of continuity: in a sense, you retain an after-image of the previous burst of light. But the camera records only what it sees when the shutter is open. To make such displays look as impressive as memory insists they were, you don't need much extra equipment, but you do need to play a few tricks.

● **Estimate exposure** — don't use a meter. As a starting point for displays on the ground set the shutter to 1/30 and divide the film speed by 30 to find the approximate aperture.

● **Use a time exposure** for aerial displays. Keep the shutter open on B by using a cable release and cover the lens with its cap when there is a lull in the proceedings. To select aperture, divide film speed by 10. Be sure to select a good vantage point. You will find that a lens of between 95mm and 135mm gives the best results.

● **Use a tripod** and a time exposure if you want silhouettes as a backdrop to the display.

▼ A dozen sparklers made the fiery patterns below.

● **Use flash** in combination with long exposures to catch recognizable views of spectators in front of the display. Try firing several flashes on a single frame.

● **Use sparklers** to trace patterns and outlines during a long exposure. Outlines call for the camera to be mounted on a tripod: dress in dark clothing and follow the edge of an object or a figure with the sparkler. Then fire a flash to fill in detail.

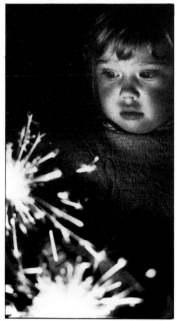

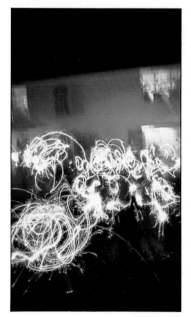

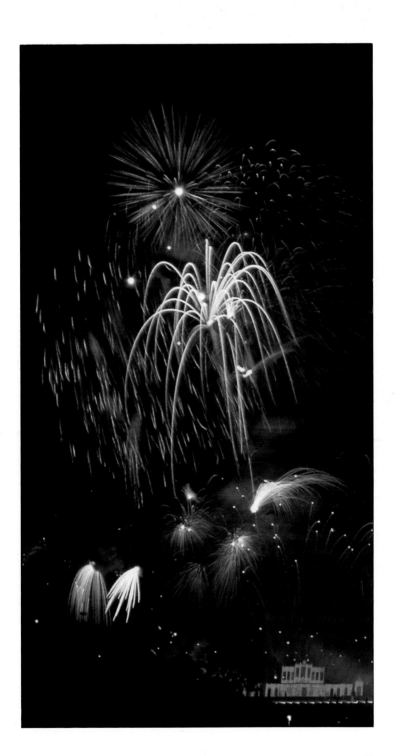

USE STROBOSCOPIC LIGHT

Some of photography's most intriguing and beautiful effects are created by recording a moving subject as a sequence of frozen, overlapping images. You can build such images with a strobo-scopic unit, which fires up to 20 flashes a second at speeds of up to 1/25,000, or, less expensively, with an automatic flashgun.

● **Use** a plain, dark background and make sure that the flash lights only the subject.

● **Keep** the action simple: one subject is enough, at least to start with.

● **Set** the camera on a tripod.

● **Choose** a small aperture to ensure adequate depth of field.

● **Use guide numbers** to determine the exposure for one flash.

● **Use** a locking cable release to keep the shutter open on the B setting.

● **Fire the flashgun** at intervals determined by the subject. A slow dance movement may look best with, say, eight flashes over 10 seconds.

● **Put coloured filters** on two or more flashguns to get more colourful effects.

● **For fast action,** use a true strobe unit.

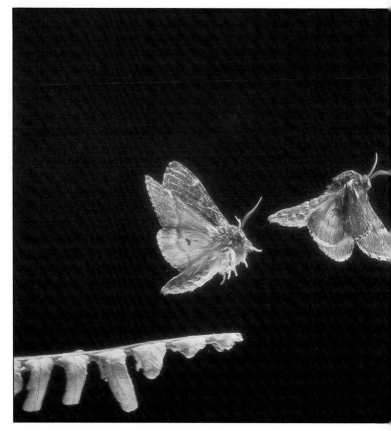

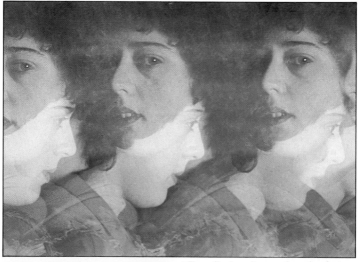

▲ Four flash units synchronized at 10 flashes a second were fired during a two-second exposure as the girl walked in front of the camera, turned, and ran back.

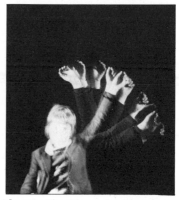

▲ Images like this can be taken with a single automatic flashgun.

◄ A strobe lamp fired every 1/125 of a second at 1/25,000 to freeze the moth flying in a glass corridor.

TAKE PICTURES IN ZOOS

Nature provides millions of subjects, ranging from domestic pets to underwater plants, and in this section of the book you will find ways of capturing them on film. Zoos are a good place to start. Zoo animals are often cleaner and sleeker than their free-roaming counterparts and with a little ingenuity you can conceal the bars, glass and concrete that separate them from you.

● **Use shadows and sunlight.** Wait until the animal you are photographing moves into a pool of light, then frame it against an area of shadow. The dark background will conceal the true nature of the surroundings.

● **Pick your moment.** Many zoo animals alternate between periods of frenetic activity and pacing boredom.

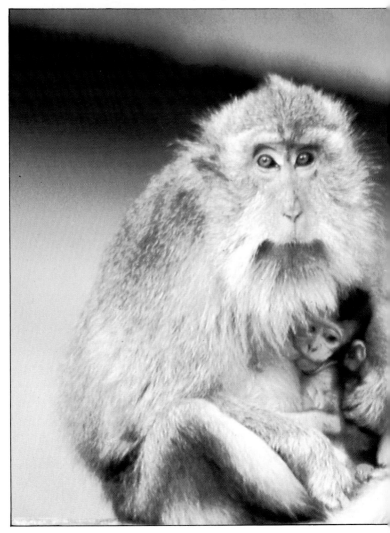

● **Try panning.** Set a slow shutter speed and pan to follow a moving animal (see page 86). This makes the background a series of abstract streaks.

● **Use a wide aperture** and press your lens close to the glass, bars or mesh. This way, the shallow depth of field will disguise the barrier.

● **Close in** with a telephoto lens or teleconverter. The narrow angle of view means that smaller patches of foliage will be big enough to make an adequate background, and the telephoto's shallow depth of field softens and hides obtrusive background detail.

▼ A 250mm lens, set at ƒ4, kept the baby monkey and its mother sharp, but blurred an obtrusive background, softening detail and helping to create overall colour harmony.

CLOSE IN ON PLANTS

Plants are the simplest of natural subjects to photograph in close-up. As they stay rooted in one place, you can take all the time that is necessary to obtain the best possible picture. And since many plants are quite large, you don't always need elaborate close-up equipment in order to fill the frame.

● **Use close-up lenses** for larger plants. These lenses are cheap and screw into the front of your regular lens like a filter.

● **For tiny objects** use a macro lens or extension tubes. Though quite costly, these accessories produce high-quality results.

● **Protect plants** from wind by using a wind break or your body.

● **Use a reflector** to fill in the shadows and reduce contrast.

● **Avoid excessive exposure** calculations by using your camera's meter. Close-up lenses require no compensation, but macro lenses and extension tubes reduce the amount of light reaching the film. If using a TTL (through the lens) meter, compensation is automatic.

● **Use a tripod** and cable release to minimize camera shake.

● **Stop the lens down** to maximize depth of field when you are working close to the subject.

● **Use fast film** or flash to help overcome the problems of depth of field or movement.

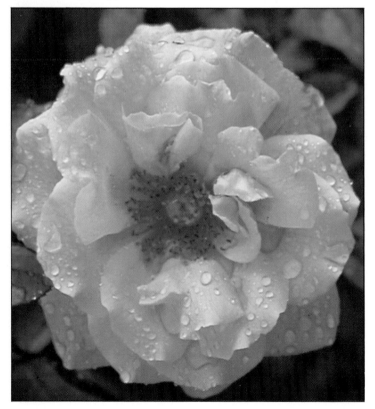

▶ Subjects as large as this sunflower don't usually represent too much of a problem. A shutter speed of 1/125 and an aperture of f8 with a 100mm lens were sufficient to freeze the subject and fill the frame.

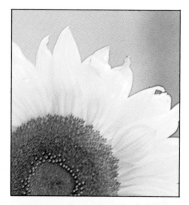

▼ An early start was necessary to capture the frost gleaming from these autumnal leaves, which a 50mm macro lens has isolated.

▶ For this dew-covered rose I used a close-up lens; but note that depth of field was not enough to render the whole bloom in focus.

PHOTOGRAPH WILDLIFE

Wild animals present special photographic problems: the biggest difficulty is getting close enough to the beasts to fill the frame of the viewfinder.

A hide like the one below makes this very much easier, but there are also a number of techniques that you must master if you are to avoid photographing only the vanishing tail of your quarry.

● **Use a long lens:** you may be able to get away with a 200mm, but a 400mm lens is a better all-rounder. Buy the lens with the widest maximum aperture you can afford, so that you can use faster shutter speeds to eliminate any movement or camera shake.

● **Fast film** allows faster shutter speeds with limited apertures to retain depth of field. Slow film can be used in bright sunlight, or if your subject is fairly approachable.

● **Read about your subject.** The more you know about the animal's habitat and behaviour, the simpler it is to approach and photograph it without disturbing it.

● **Lay bait.** You'll be surprised at the range of wildlife that appears if you put out bait regularly. The fox, below, was wary and difficult to photograph, so I let out some chickens (rescued in time), the fox became intent on the chase, and I captured a characteristic shot.

● **Stay upwind** of your quarry. Animals have a highly developed sense of smell.

● **Use a hide.** It can be as simple as a blanket over your head, with a hole cut for the lens.

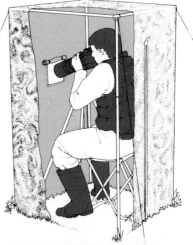

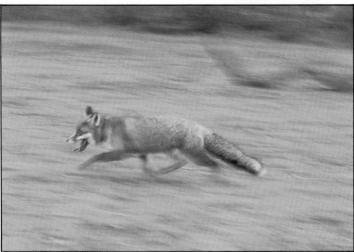

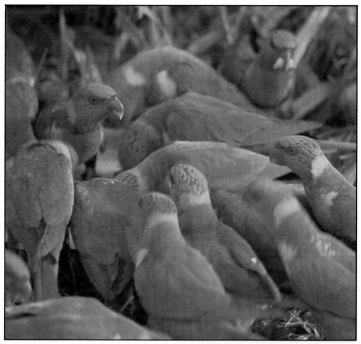

▲ The camera needed extra support for this evening shot of Australian parrots, taken with a 200mm lens at 1/60. If a tripod is too cumbersome use a monopod or improvise support.

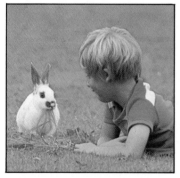

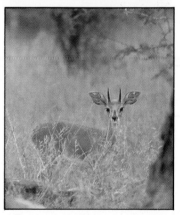

▲ A 200mm lens ensured that the camera did not disturb boy or rabbit. Be patient with animals: it may take several hours before your subject appears and is at ease in your presence. Make yourself comfortable and keep off the horizon.

▲ The best wildlife picture always shows the animal in its natural habitat. Selective focusing helps to pick out animals from a background that provides them with natural camouflage, as in this shot of an impala, taken with a 400mm lens. Always put animals before photographs — remember that if you approach too close to an animal's lair you could force it to abandon its young.

CLOSE IN ON NATURE

Insects and small animals can be especially difficult to photograph. Close-up work always offers problems of focus, depth of field, and lighting. These are made greater when the subject is likely to dive into a pond or dart off into the undergrowth. You may need to use bait to tempt an animal to sit still for a minute or two, or use a motor drive operated by remote control.

● **Use a long focus lens** — either a telephoto with extension tubes or a 100mm or 200mm macro lens. This will enable you to fill the frame from a greater distance, and thus avoid disturbing the subject you are photographing.

● **Wait** until the animal settles down before taking the photograph. Animals feed only when they are relaxed: you can be fairly sure that an animal that is eating will ignore the sound of the shutter.

● **Move** the camera to focus rather than turning the focusing ring. By moving back and forth you can focus more quickly with equal accuracy.

● **Confine your subject** in an aquarium or a box. By limiting its movement in this way you have more control over it, and over other factors such as the lighting and the background.

● **Render** creatures inactive. Cold-blooded animals and insects move more quickly when warm, so by putting them in a refrigerator for ten or 15 minutes you can slow down their activity. The treatment does no harm provided you don't overdo it.

▸ Underexposure by half a stop helps increase colour saturation in close-up photographs. It pays to load with fast film and to use fast shutter speeds.

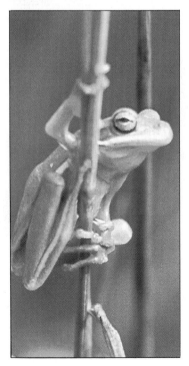

▲ When the camera-to-subject distance is too short, focusing with a standard lens is impossible. By fitting extension tubes or a set of bellows between the camera and the lens, you can focus close up. Without TTL metering, use exposure tables, not a light meter, because effective f number is decreased by bellows or tubes.

◀ The characteristic problem of close-up photography is the limited depth of field, which becomes more restricted the closer you focus. In this instance the shallow depth of field is an advantage.

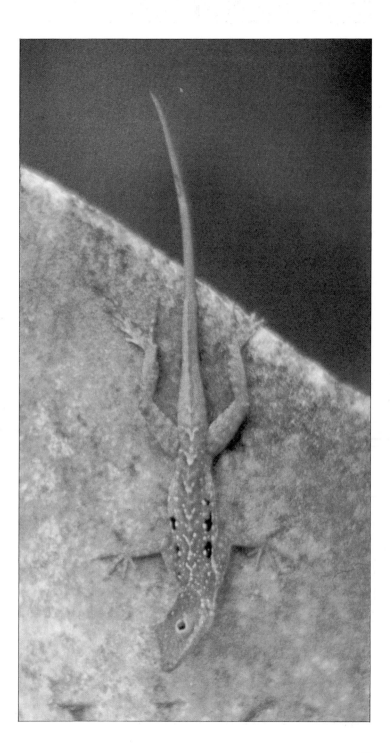

STOP BIRDS ON THE WING

Birds in flight are usually difficult to photograph, calling for impeccable camera craft and fast reactions. However, if you know enough about the habits of one particular bird, and use the technique below, you can greatly simplify the problems.

● **Set up the camera** near the bird's flightpath. This is easiest when the bird is nesting, because most birds returning to a nest will perch on a particular branch some distance from it, and look around, before finally approaching it.

● **Focus on one point** through which you know the bird will fly (see pages 84-85).

● **Set up a flash unit** to light the bird in flight. Use it on manual setting and find correct exposure by testing. Two units will make the light look more natural.

● **Automate the camera** — so that the bird takes a self-portrait — by using a light and a photo-electric cell. These will operate the camera when the bird flies through the beam.

▲ Weak daylight, fill-in flash, and 1/125 enabled me to blur the wings of the owl. Always put the bird first — never threaten its health or interrupt its breeding cycle.

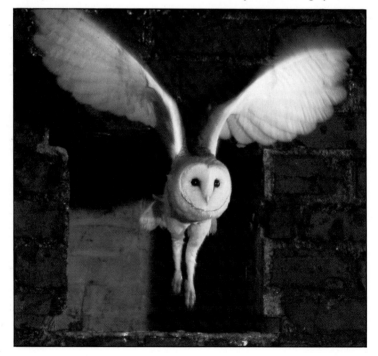

RECORD AQUARIUM LIFE

Underwater photography doesn't necessarily mean donning diving gear and buying an underwater camera. If you have access to an aquarium, you can photograph fish with your regular camera in conditions over which you have complete control.

● **Divide up the tank** with sheets of glass (right). The glass is invisible in the water, but keeps the fish close to the camera.

● **Move the camera close** to the tank to eliminate reflections of the room behind.

● **Position a flashgun** above the tank or to one side. Flash stops movement and lets you use a small aperture, so focusing isn't critical.

● **Improve the setting.** Card or plastic behind the tank will change the background colour.

● **Use backlighting** to show the translucent nature of the bodies of some small fish.

● **Turn out the room lights** but use a table lamp above the tank to aid focusing. A darkened room helps to prevent reflections.

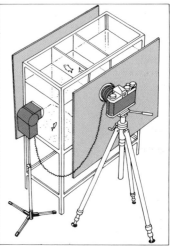

▲ Make sure the glass of the tank is clean and the water clear. Fit a polarizing filter to minimize reflections and don't use photofloods — they heat the water.

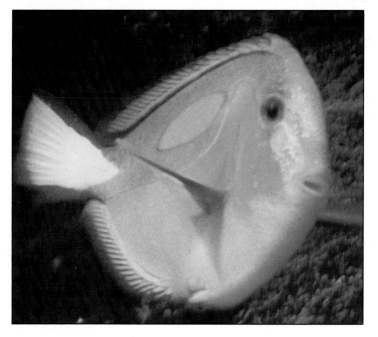

PREFOCUS ON ACTION

Action photography may seem fraught with difficulties. Stop the action with a fast shutter speed and you lose the impression of movement; fail to do so and blur may make the subject unrecognizable. How, if you want to photograph a spectator sport, do you get close enough for impact? How do you cope with fast movement in low light? How do you focus on a moving subject? If the action is dangerous, or too far away for you to get close to it, or confined behind barriers, what do you do? The next 10 pages deal with these problems, beginning with that of focusing. One answer is to set the focus in advance and to wait until the subject is sharp before releasing the shutter.

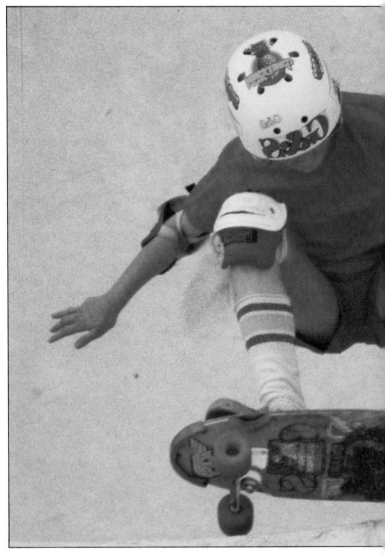

● **Select your viewpoint** with care. Many subjects almost stop at some point and by pre-focusing on it you can choose your moment more easily. If the subject curves, pick a viewpoint from which it crosses the frame rather than advances or recedes.

● **Press the shutter** release an instant before the subject reaches the point of sharpest focus. There is always a short delay between pressing the release and the shutter's opening.

● **Practise** with unimportant subjects. Use black and white film and don't bother with prints — you can check focusing accuracy on the negatives with a magnifier.

▼ Prefocus and 1/1000 stopped the movement of the skateboarder.

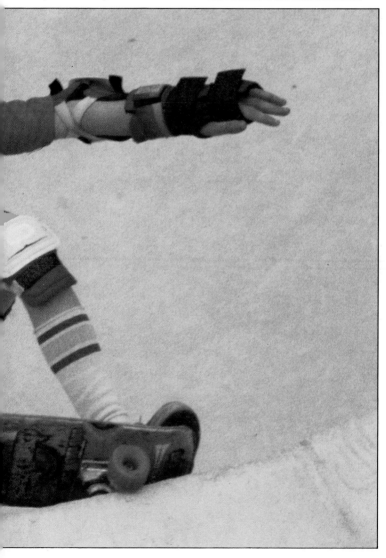

PAN WITH THE ACTION

Panning the camera — swinging it to follow a moving object — gives the photographer a unique way to represent movement. Using this technique, a single photograph can incorporate both a crisp image of the speeding subject and a background of impressionistic streaks that sweep the viewer's eye across the frame.

Because panning simply involves smooth, controlled movement of the camera, special equipment is unnecessary — the technique is equally suitable whether you own a cheap snapshot camera or a sophisticated SLR.

● **Choose a position** where the subject will pass directly across the camera's field of view. Don't stand too close, both for safety reasons, and because if the action fills the frame, you will find it hard to avoid cropping off bits of the subject. At its closest, the subject should cover no more than half the width of the frame.

● **Stand comfortably** with your legs apart. Make sure that you can swing freely both left and right.

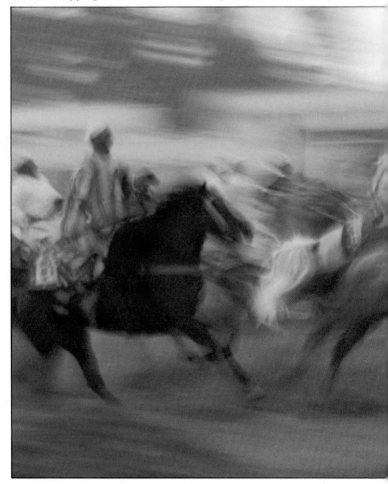

● **Prefocus the camera** on the point where you expect the subject to be at the moment when you press the shutter. This way you'll have one less thing to worry about at the moment of exposure.

● **Frame the subject** as soon as it appears in the distance. But resist the temptation to refocus.

● **Choose a slow shutter** speed — 1/60 to 1/15 — and release the shutter smoothly just before the subject is ideally positioned.

● **Turn your whole body** from the waist — don't just turn the camera

— and follow through by tracking the receding subject. Don't just stop as soon as you hear the shutter fire, or the panning action will be less smooth.

● **Practise panning** by standing at the edge of a busy road. Start without film, then load the camera as soon as you're more confident of your panning skills.

● **Watch the background.** Plain backgrounds tend to reduce the impression of movement. Avoid light backgrounds, as these may cause a kind of ghost image on the picture.

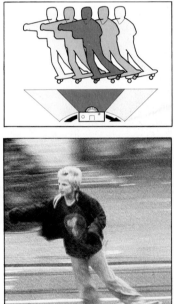

▲ As shown in the diagram, a pan should begin some distance before the button is pressed and continue after exposure is completed.

◀ I used a slow shutter speed (1/15) to intensify the action of these galloping Berbers. Faster moving subjects, such as racing cars, will need a faster shutter speed (up to 1/250) as well as a more rapid panning action.

CLOSE IN ON ACTION

Telephoto lenses get you close enough to fill the frame in difficult or dangerous situations. They also dramatically compress the middle and far distances, which adds impact to distant subjects.

● **Use a 200mm lens** or longer to create pictures with compressed space.

● **Use fast film** with long lenses because the maximum aperture on most is $f4$ or $f5.6$.

● **Stop down** if possible. Depth of field with telephotos can be very limited.

● **Support the camera** with a tripod or monopod.

● **Use fast shutter speeds,** particularly if you are hand-holding the camera.

▼ The dramatic picture of a firejump was taken with a 400mm lens. Without it, I could not have got close enough to the subject.

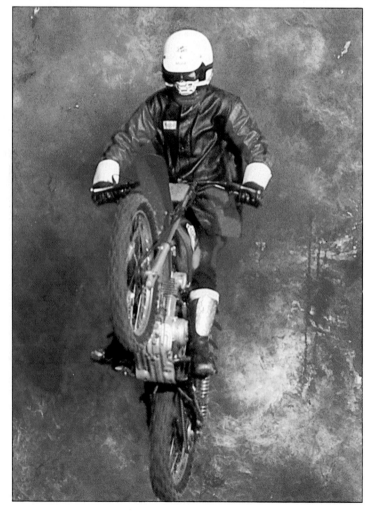

ZOOM IN ON ACTION

Changing the focal length of a zoom lens during the exposure creates a tunnel of lines converging on the centre of the frame. Used with discretion, this technique can add pep to a mundane subject and excitement and action to an otherwise static scene.

● **Set a slow shutter speed** such as 1/8 or 1/4 so that you have time to operate the zoom while the shutter is open.

● **Use a small aperture** with aperture priority cameras. The camera will then select an appropriately slow shutter speed.

● **Add grey filters** (neutral density) if bright sun and fast film won't let you set a slow enough shutter speed.

● **Frame the picture** with a recognizable part of the subject at the centre of the viewfinder

because everything else will be streaked and unrecognizable.

● **Use colour film.** Zoom effects can look drab in black and white.

● **Hand-hold the camera** if you wish. The zoom will mask the effect of camera shake.

● **Crop the print** so that the converging lines do not meet at the centre. Many people find precise symmetry disconcerting.

▼ The best 'speed lines' result from a background in which highlights and shadows mix.

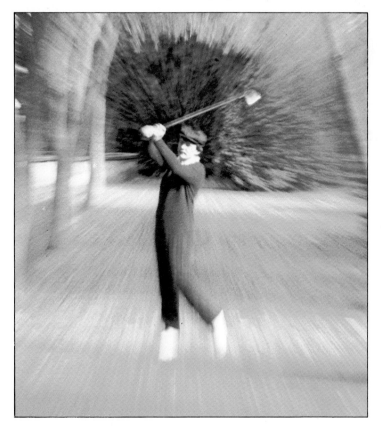

FREEZE FAST ACTION

Some of today's cameras have shutter speeds as fast as 1/4000 of a second — and if you are prepared to pay a high price for a high speed, you'll get a camera that will freeze most action. But even with more modest equipment you can still get sharp pictures of rapidly moving subjects by taking the steps suggested here.

● **Roll with the action.** If you are moving at the same speed as the subject — as I was when I took the water skier below — the negligible relative movement lets you use 1/1000, a speed most SLRs have.

● **Use fast film,** which will let you select a fast speed.

● **Use electronic flash** if the subject is near you. It will arrest all movement (see page 58).

● **Choose camera angles** carefully. If the subject is advancing or retreating you can freeze it with a much slower speed than when it is crossing your field of view.

● **Keep your distance.** Objects can appear almost static when they are a long way off.

▼ A shutter of 1/500 was enough to freeze the boy and ball below. The show called for skilful timing.

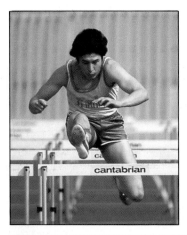

◀ It is important to choose the right moment to take the picture. I used a 400mm lens to catch the hurdler in full flight.

▼ The water skier was taken from the towing boat with a 135mm lens and a shutter speed of 1/1000.

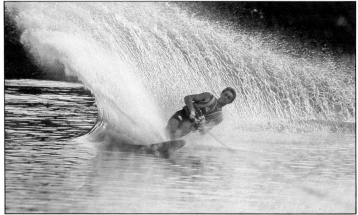

USE REMOTE CONTROL

Until recently, motor-drives were for professionals. Now, they are relatively common — some cameras even have them built in. Linked to a remote control system, a motor-drive not only gives you a better chance of taking the perfect action picture, it also lets you take as many as you like without going near the camera.

● **Use remote control** to get two views of the same event. Set a motor-driven camera on a tripod in one position and trigger it from where you stand with a second camera.

● **Use a cable** with a simple push-to-close switch for the most reliable remote-control connection.

● **Set exposure manually** rather than relying on automatic control. If a cloud crosses the sky as the shutter fires, take a meter reading and adjust exposure by pushing or pulling the film

● **Avoid radio control** because stray radio transmissions (from personal transmitters) can fire your shutter prematurely. Use an electric cable or an infrared release system.

▼ Remote control was the technique used to catch different views of a display by the Imps Motor Cycle Display Team.

◄ Pre-planning is essential in taking several pictures of the same piece of action. In this case I chose my viewpoints well in advance and used remote control to trigger two of the three cameras.

LIGHT INDOOR SPORT

Light levels at indoor events are rarely high enough to enable you to take pictures — so you will usually have to use supplementary illumination such as flash. Position your flash unit carefully to retain the atmosphere of the setting. Avoid flat, uninteresting lighting schemes.

● **Ask permission** before using flash at any sporting event. A sudden burst of light can ruin a competitor's concentration. You may be asked to take pictures at a training session rather than during the event itself.

● **Position the flash** to one side of the subject and slightly above, if possible.

● **Use a second flash** on the camera to fill in any shadows created by the first unit. Make sure that the on-camera flash does not create double shadows.

● **Synchronise flash units** using a cable and a 'Y' adaptor in the camera's flash socket. Or, for more freedom of movement, use a slave unit to trigger the off-

camera flash. You can use as many slave units as you wish.

● **A long shutter speed,** such as 1/4, combined with flash, will record both a sharp image and a gentle blurring that suggests the excitement of the activity.

● **Use on-camera flash** to create a sense of immediacy and excitement — but don't expect the results to be particularly flattering to the competitors. With some types of event, this is not too important.

● **Don't use flash** when there are television lights present. These are bright enough for available-light shots on fast film, and are balanced for daylight.

▲ Sometimes a general shot of the auditorium tells you more about the event than a close-up of the action. Also, the wide maximum aperture available on a standard lens, coupled with fast film, allows you the freedom of taking advantage of available light for your shots.

▶ The picture of the gymnast was lit from the rear right by a strong spotlight that established a suitable atmosphere. I added an electronic flash from the same direction and another unit at front left. An exposure of 1/30 picked out background flare and flash froze the movement.

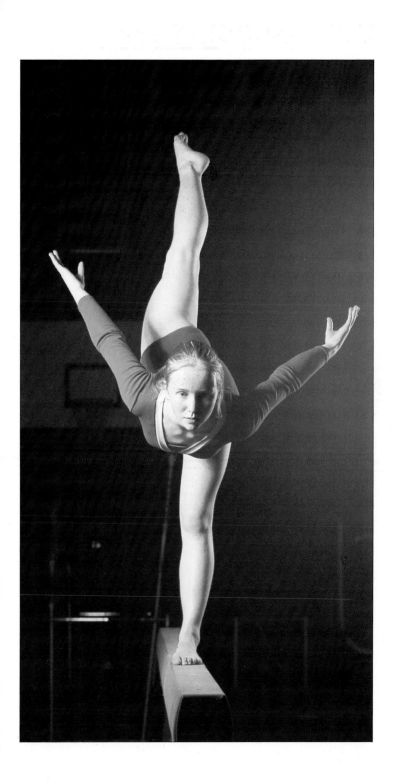

SHOW A SWEEPING VISTA

Landscapes, seemingly among the easiest of subjects, have their own special difficulties, dealt with in the pages that follow. The fundamental difficulty is of capturing on film the majesty that delights the eye. Because the eye views a scene by constantly sweeping it (and changing focus), reason suggests that a wide-angle lens might be the answer. But to get a similar field of view, you would have to use several lenses. The right answer is to see landscapes with a painterly eye and be selective.

● **Evaluate the scene** before even getting out your camera. Decide what it is that gives the landscape its charm and consider how you can best bring out those qualities. Don't just snap.

● **Close in on a part** of the scene that sums up the whole. In the picture below, I realized that the haze-veiled buildings were what gave size and scale to the view, so I made them the focal point of the picture.

● **Blow up the negative** or slide to a scale that does justice to the original scene. Part of the awe-inspiring nature of landscape lies in turning your head to scan the view. A large print allows its viewer to experience the scene just as you did when photographing it.

● **Crop the image** — don't assume that the print has to be the same format as the negative. Our experience of landscape is largely horizontal, so try trimming a large slice from the top and bottom of the picture to make a long, low scene.

CAPTURE DAWN AND DUSK

Dawn and dusk make irresistible subjects for the camera: shades of russet, azure, pink and gold demand your attention. And although the contrasts between dark and light are often too great for any film to copy accurately, there is much you can do to make pictures more colourful and dramatic.

● **Meter from the sky,** not from the ground or from the sun.

● **Bracket your pictures** (three stops should be enough). It's hard to know which setting will give the best results.

● **Work quickly** if you want to catch the sun actually touching the horizon.

● **Use flash** to retain foreground detail. Strong back-lighting will otherwise create silhouettes.

● **Slide film** records the intensity and vibrance of colours more accurately than print film.

● **Pay** for good-quality prints if using negative film. The extra money spent will result in richer, more accurate colours.

● **Read the papers** to find the times of sunset and sunrise — then you can make sure that you have a few minutes to prepare.

● **Use a compass** to note the direction of the sun at dawn. The following day you'll be able to set up in the best position.

● **Use a tripod** with a pan head to make a panorama of the rising or setting sun. Make sure that the camera is level as you pan and that the frames overlap sufficiently. Try to include some buildings or trees.

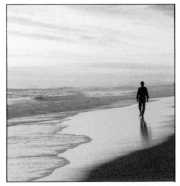

▲ Water has been used to reflect and intensify the delicate colours of the sky just before dawn.

▼ Failing light at dusk reduces the enclosing hills to silhouette, while detail in the town is maintained by the green glow of fluorescent street lighting stretched along the waterfront.

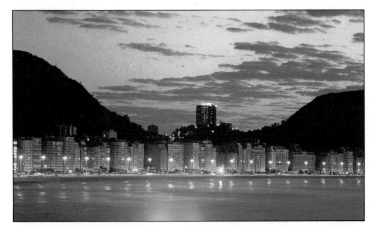

▶ Take a reading from a weak sun about 25° off centre and vary exposure a stop either side.

▼ Shots that include the setting sun can have dramatic impact if taken with a long-focus lens. This type of lens tends to squash perspective, making any object in the background loom larger than it would normally appear. With shots like this, it is always best to bracket your exposures.

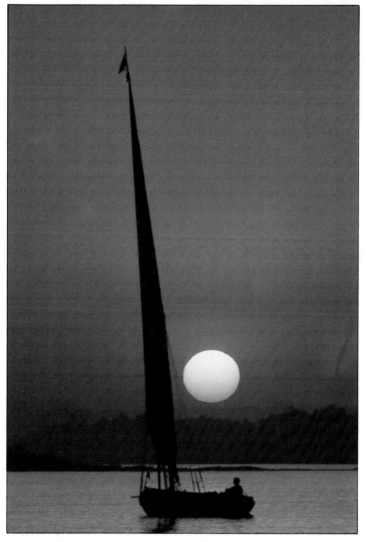

FREEZE AND BLUR WATER

Like a flickering flame, a body of moving water has the capacity to hypnotise the viewer. On film, water is just as fascinating — altering shutter speed enables you to record running water as silky smooth or as hard as crystal.

● **Use fast shutter speeds** — the fastest ones your camera offers — to record water as clearly defined, glassy splashes. In sunlight the water will sparkle, and you should still be able to set a reasonably small aperture for extended depth of field.

● **Use slow shutter speeds** — five seconds or more — to make running water seem to float like a soft mist. Even with slow film and the smallest aperture, over-exposure may still be a problem. If so, use a neutral density filter. The ideal filter has a density of 1 — and transmits only 1/100 of the light falling on it, allowing you to use far slower speeds. A firm camera support is essential and you may need a cable release and to time your exposures manually.

● **More lifelike results** are obtained using speeds of 1/60 or 1/125. At these speeds the water will record in much the same way as it appears as you view the scene.

▲ Quick reflexes and an observant eye are necessary to capture waves crashing onto the shore.

▼ A shutter speed of 1/250 was insufficient to freeze the motion of the water as it thundered down the falls at Niagra, dwarfing the huddled spectators below.

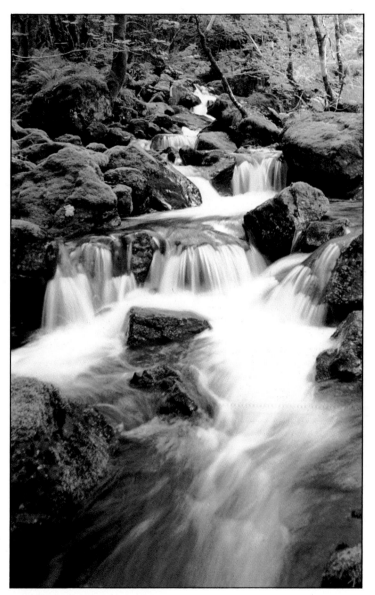

▲ Tumbling streams have great
pictorial appeal. The effect above
was created by using a shutter
speed of 1/15 — slow enough to
spread out the movement. The
velocity of rivers varies so much
that it is usually necessary to
bracket exposures if you want
to achieve a precise result.

INTENSIFY COLOURS

Colourful landscapes don't always make brilliantly coloured photographs. Haze or sun flare can bleach the brightest scene, but you need take only a few simple precautions to record colours as rich and pure as they appeared to the eye.

▲ Yellow dominates the picture, but is a colour that harmonizes with green — and thus produces a pleasing effect. The level of colour saturation has strengthened the composition.

● **Use a lens hood** to remove non-image-forming light.

● **Colours are richest** in the early morning or late afternoon. Top lighting weakens colour.

● **Underexpose** about half a stop with slide film, or slightly overexpose negative film, in order to brighten colours.

● **A polarizing filter** cuts out glare from the surface of water or foliage, making hues look cleaner and purer. Rotate the filter and note the strongest result as you look through the lens.

▼ Slight underexposure has intensified the range of hues between blue and green in this aerial shot of sea and reef.

PHOTOGRAPH SKIES

Every photographer knows that dramatic skies make for dramatic landscapes, yet very few seem to point their cameras upwards and make the sky the subject of the picture. If the weather is windy, the sky will be constantly in motion, so even if you just stay in the same place you will be presented with an infinite variety of changing patterns and lighting effects.

● **Use filters** to add drama and increase colour saturation. A polarizing filter will make a blue sky bluer and darker without affecting the clouds, so strengthening contrast.

● **Bracket your pictures** by making a series of exposures using different apertures or shutter speeds. Often you will find that over- or underexposed pictures have more impact.

● **Watch the weather** and don't be discouraged by rain and storms. The air seems much clearer just after rain, and colours more intense.

● **Get up early** or go out late. The sky is generally at its most spectacular in the first and last three hours of the day.

● **Try black and white film** with a red filter. A blue sky will turn black, bringing the sense of an impending summer storm.

▲ Approaching storm clouds contrast vividly with the sparkling hues of green and gold in the landscape below.

▸ The glowing colours and extra-ordinary definition of this rainbow contrast well with the plain greys of the rain clouds.

MAKE SNOW LOOK WHITE

A fall of snow transforms the landscape, but the brilliant white mantle presents special problems to the photographer. Careful control of exposure and colour rendition is essential if the snow is not to reflect colour from its surroundings.

▲ Falling snow diffused the image of the two boys. I took the picture through a closed window with a 400mm lens. Exposure was 1/250 at ƒ8 on Ektachrome 200.

▼ In contrast, I used a 100mm macro lens for the picture of frost-rimmed trees against a misty sky. The exposure, just sufficient to reveal detail, was 1/250 at ƒ5.6 on Ektachrome 64.

● **Meter carefully.** The brightness of the reflected light can mislead your camera's built-in meter. There are three ways to avoid this:

● **Close in** on the main subject so that snow doesn't fill the frame. Meter and then move back to recompose the picture.

● **With a hand-held meter,** measure the light that falls on the scene, rather than that reflected. This is an incident light reading — point the meter's diffusing dome at the camera from the subject position. Keep footprints out of the image area.

● **Underexpose** — set your meter to three times the speed of your film and bracket shots.

● **Filter carefully.** Snow picks up colour casts more easily than other scenes. In overcast weather use an 81C filter, and when the sky is blue and the scene totally in shadow, use an 81EF filter. In bright sunlight no filter should be necessary. A polarizing filter will cut glare.

TAKE AERIAL LANDSCAPES

From the air the countryside takes on a completely new perspective. Hedges and trees shrink to the size of small lines and dots, and the whole panorama becomes a tapestry of colour and abstract pattern, spreading out in all directions.

▲ Shadows and form, created by oblique light, make this aerial shot realistic, not abstract.

▼ Seen from a low-flying aircraft, terraced rice fields reveal strong patterns through the interplay of light and colour.

● **A high-winged plane** gives you an unobscured view of the scene below.

● **Avoid shooting through** acrylic plastic windows.

● **Fly low** if you can to minimize haze. Otherwise, take pictures on take-off and landing.

● **Use a standard lens** or a wide angle. Vibration will cause image blur with longer lenses.

● **A polarizing filter** will reveal rainbow-coloured fringes in plastic windows.

● **Depth of field** is no problem, so pick the optimum aperture for your lens and adjust the shutter speed accordingly. Avoid slow speeds in case of vibration.

EXPLOIT HAZE AND MIST

Even on clear days, the atmosphere contains particles of dust and water vapour that make the distant horizon appear bluer and paler than the foreground. When recorded on film, this produces an effect of distance and depth which you can manipulate and exaggerate to add to the sense of three dimensions in your pictures.

▲ Thick midday fog was so dense I needed a shutter speed of 1/15 for this lakeside shot. 1/125 at ƒ8 was adequate to capture the mist trailing gently over the rocky land-scape of the Scottish Highlands.

● **Use a telephoto lens** or a teleconverter. This will magnify the misty portion of a scene.

● **Shoot late in the day** when a low sun exaggerates mist. Early in the morning you may catch mist where it gathers in hollows.

● **Use a pale blue filter** to emphasise the natural blueness of haze and mist. With black and white film a deep blue filter can be equally effective.

● **Find foreground detail** and position it prominently in the frame. This will contrast the pale blue distance with the harder lines of the nearby object.

● **Hold the camera vertically.** This will ensure that the broadest dimension of the frame encompasses both nearby objects and the distant horizon.

● **Avoid** side lighting as it tends to reduce haze and mist to a minimum.

● **Remove** a UV filter if you keep one on your lens.

CONTROL SCALE AND SIZE

The photographer's golden rule that 'telephotos compress space and wide angles expand it' is really only partially true. The angle of view influences the perspective within the picture and will give a greater illusion of space.

● **Pick a close viewpoint** to exaggerate size relationships. From close up, even small objects loom larger than more distant objects — however big these may be. If it is important to take in the whole of the nearby object, you may have to use a wide angle lens — hence the common misconception that wide angle lenses expand perspective.

● **Pick a distant viewpoint** to portray size relationships as they really are. In the picture right, for example, the trees are dominated by the mountain behind. From a close camera position, the mountains would have looked smaller in relation to the trees. To fill the frame with a distant subject, a telephoto lens may be necessary — and so it is easy to make the assumption that it is the lens, not the viewpoint, that is the sole influence on scale.

▲ A distant viewpoint and a standard lens has rendered a very natural sense of scale and size in this mountain shot.

▼ I used a close viewpoint and a wide angle lens (below left) to exaggerate the apparent convergence of the ploughed furrows. By angling the camera down (below), the nearer subjects appear larger than they otherwise would.

COPE WITH THE ELEMENTS

Weather not only affects the subjects you are photographing, it also affects your equipment and film. Humidity, and extremes of temperature, will produce mould on camera bodies, run down batteries, cloud lenses and alter the colour balance of film.

In rain . . .
● **Put your camera** in a plastic bag, with a hole cut for the lens. Protect the lens with a uv filter.

● **Dry the camera** as soon as possible and don't touch film with wet hands.

In the cold . . .
● **Keep batteries warm.** Put a spare set in an inside pocket and use them when those in the camera begin to flag. Or keep the camera warm under a coat.

● **Use zooms** to minimize lens changing. Breath can condense and freeze on the camera's mirror.

● **Wind film slowly** and don't use a motor drive. Cold film is brittle and generates static electricity that fogs film.

In heat . . .
● **Don't leave your camera** in the open. Extreme heat may melt the cement between lens elements.

● **Refrigerate film** and carry only as much as you need for a day.

● **Process film promptly.**

In the tropics . . .
● **Pack equipment** in plastic bags with silica gel.

▼ I set up my camera on a tripod under an umbrella to take a rainy day in Sardinia at 1/8 and ƒ8.

▲ Sand and salt water are two of a camera's greatest enemies. Fit an ultraviolet filter and carry the camera in a plastic bag. Clean the camera every night.

► If possible, take pictures quickly in cold conditions. Keep the camera covered between shots. Hold your breath in case clouds of condensation obscure the lens.

▼ In high humidity, take your camera out of air conditioned buildings half an hour before you want to use it or condensation will form on the lens.

CAPTURE NIGHTLIGHTS

Straightforward photographs of night scenes often prove to be disappointing — all that appears is a pattern of small dots of light on a plain black background. To incorporate some of the glitter that you see through the viewfinder, use some of the tips below.

● **Shoot at dusk** rather than at night. This will enable you to capture outline details rather than just blackness.

● **Move close** to some of the lights, so that they record as larger than those farther away. This

variation in image size will prevent the lights appearing as a pattern of equal-sized dots.

● **Wait for a wet night.** In wet weather, reflections from streets and rooftops will double the sparkle in the scene.

● **Use a long exposure** so that speeding cars leave curving trails of light (see page 66).

● **Try a range of apertures.** You may find that your lens turns the lights into stars at small lens openings.

● **Zoom during exposure,** so that the lights form converging streaks.

● **Gradually defocus** the lens in the course of a time exposure and each light source will turn into a pool of colour.

● **Fit a starburst** or a diffraction filter. This will form multi-spiked stars from each source of light (see page 129).

▼ An exposure of about one minute at ƒ16 captured Blackpool tower at night. The most common fault in such pictures is underexposure: deliberate overexposure adds brilliance.

CHOOSE A VIEWPOINT

Seen from different viewpoints, a building may appear to have several quite varied faces. From close to a single structure will totally dominate your photograph; yet from afar, that same building will have a different relationship with its surroundings.

● **Change scale.** Your subject does not have to fill the frame precisely. In windy weather, for example, clouds speed across the sky, sweeping shafts of light across an otherwise bleak cityscape. Caught in such a pool of brilliance, a single structure might be spotlighted and drawn out of its surroundings.

● **Use available frames** to draw attention to one particular building. A suitable frame may be another building, a doorway, an arch or a window used to enclose the main subject.

● **Don't stay rooted** in one spot. Changing lenses has no effect on perspective if you stand still. Different focal lengths simply alter how much of the subject your picture takes in.

● **Look up — look down.** The vast majority of photographs are taken from eye level. That's why the other photographs look so unusual. From a worm's eye view, even your garden shed will appear to be a massive, dominating structure.

▼ Careful selection of viewpoint shows the powerful yet graceful bulk of the windmills in a straightforward way, creating also a strong sense of perspective.

▲ The hard, linear roof struts of a swimming pool make the perfect frame for this shot. A 15mm wide angle lens ensured adequate depth of field.

▲ Good architectural photography relies very heavily on the right light for the subject. In this shot of a pier in Yorkshire, strong sun would have given the roofs and their sharp shadows undue importance. As it is, slight gradations of tone and colour can be explored as the eye is carried downwards by the rush of the cable-car line and follows the slow expansion of the pier into the blue-grey sea. The red and blue trim of the sheds is softly repeated in the asphalt area between them and in the muted colours on the pier.

USE A SHIFT LENS

With a perspective control, or shift, lens on the camera, you can change the field of view by simply turning a knob. So instead of tilting the camera upwards, to include the top of a tall building, for example, you can keep the camera level and avoid the problem of converging vertical lines.

● **Use a spirit level** to check that the camera back is vertical. Tilting the camera makes parallel lines appear to converge.

● **Shift up** to bring the top of tall buildings into shot.

● **Shift down** to include more of the floor, or to photograph the top of a table without the legs converging towards the ground.

● **Shift sideways** in rooms with mirrors to avoid camera reflections appearing in the picture.

● **Don't shift too far,** or the corners of the picture will darken.

● **Fit a squared screen** to replace the normal focusing screen, and you'll be able to verify that lines are parallel.

● **Stop down the lens** — at small apertures you can shift the lens much farther.

● **Use the lens** to eliminate unwanted foreground.

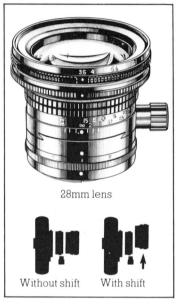

28mm lens

Without shift With shift

▲ A shift lens is designed to move up to 11mm off-centre to produce the type of perspective correction you can see below. The lenses are available in 28mm and 35mm.

▲ For the picture of the interior of St Peter's above, all I had available was a 35mm camera with a 28mm shift lens. By shifting the lens downwards a more intense feeling of the sheer volume of the space was captured. A shift lens, however, is not essential for successful architectural shots. In the example below, taken in New York, I moved well back from the group of buildings I wanted to shoot and used a telephoto lens aimed just above the street.

▲ The two photographs above illustrate how the subject is apparently displaced without tilting the camera.

MAKE ROOMS LOOK BIGGER

Photographing a room to retain its essential features, and to create a sense of space, is not difficult, but calls for attention to detail. You need to select your viewpoint carefully and you may need to rearrange furniture so that it is not obtrusive.

● **Change lenses.** A standard lens is suitable only when you're taking pictures in an auditorium. A 28mm lens is the longest that really gives a sense of true space indoors; 20mm and 24mm lenses make rooms seem progressively bigger. Lenses of 18mm and shorter focal lengths introduce distortion.

● **Use a mirror.** Interior designers often place mirrors cleverly to make small rooms look bigger. Close to the camera, a mirror can be undetectable in a photograph; even if the frame is visible, the room will look larger than it really is.

● **Shoot through a door** or window. By backing out of the room you are photographing, you increase the camera-to-subject distance and with it the apparent space in the room.

● **Make use of shadows.** Place your main subject in a pool of light and take advantage of the dark surroundings. For all the viewer knows, that dark background may stretch away into the distance.

▲ Snow reflected daylight into this Bavarian church: I used a 28mm lens, exposing for a second at $f22$.

▼ A 15mm lens at $f8$ opened up the hotel bedroom.

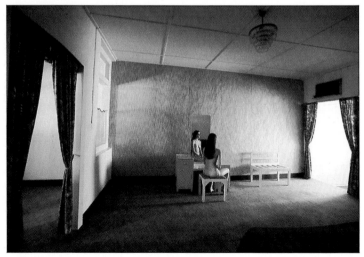

PHOTOGRAPH DARK CORNERS

To the untrained eye, normal room lighting usually looks quite even. However, if you take exposure readings from a point near to the light and from a dark corner, you will find that the most dimly lit part of a room is as much as six stops darker than a well-lit area. You can solve this problem in a number of ways.

● **Move your subject** into the light. If it is closer to a window, you may be able to hand-hold the camera.

● **Concentrate** on brightly lit areas. This is how I approached the problem of low light in the Buddhist shrine (right). It is not always essential that shadow areas of the picture retain full detail and in such situations you can take a reading from the highlights.

● **Use a reflector.** Placing a mirror just outside the frame is a quick way to double the amount of light falling on the subject. Even a newspaper reflects 80% to 90% of the light falling on it.

● **Add some light.** In domestic interiors there are usually extra lamps available. Domestic tungsten lamps will create an orange colour cast, but this often makes the room look cosy. For perfect colour with ordinary 100W bulbs, use an 80A filter and an 82B filter.

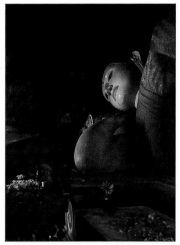

▲ Existing light was used to capture the bright colours and penetrating quiet of a Buddhist temple. I braced myself against a wall to shoot at 1/4 and f8.

▼ Moving in close with a 28mm lens threw greater emphasis on the apothecary, whose face was lit by overhead lights on his shopfront.

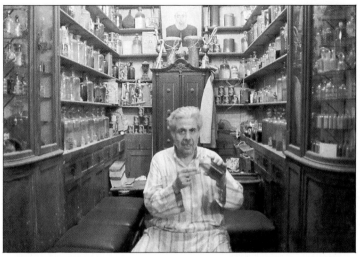

FEATURE BUILDINGS

Our experience of architecture tends to be dynamic, not static. Walking around and through a building provides us with a constantly changing view that is impossible to capture in a single photograph. Try, therefore, to build up an impression of the structure through a series of images.

● **Think** before pressing the shutter release, and remember that you are not trying to capture the picture that 'says it all'. Rather your aim is to build up a series of photographs that work together and convey a cumulative impression.

● **Look for details** that reveal more than the overall view. These sorts of features are hard to discern in a long shot.

● **Be comprehensive.** It's always better to take too many photographs rather than too few. This will leave you with the option of editing out any unnecessary shots later on.

● **Make several visits** if time allows so that you can photograph the building in different light and varied weather.

● **Lay out your images** with care and attention to detail. Arrange them in such a way that the viewer's eye moves naturally from one picture to the next, just as you scanned the building.

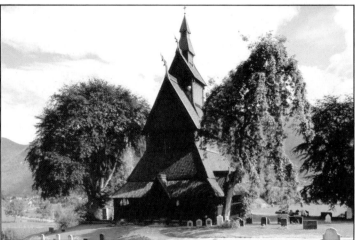

◄ Aspects of a Norwegian stave church build to a composite portrait of it. Opposite top is the canopied altar, which I took with four flashes from a small flashgun. Below that is a backlit exterior shot that brings out the contrast between the peaceful setting and the dark, sombre building. Above, I used a 100mm lens to flatten perspective of the traditional wall made of upright staves, or planks, surmounted by arches. Light gives a sheen to the tarred planks and roof tiles, but the untarred wood on the sheltered wall glows warmly through. Finally, right, I used the same lens to get a close-up view of the 'dragons' heads' that project from the gables like the prows of Viking ships.

PAINT WITH FLASH

Large interiors are often too dark to photograph by available light, even with an exposure lasting many seconds. To solve the problem, photographers have developed a technique called 'painting with light'. In essence this consists of moving around the interior with a portable flashgun, firing many small flashes. You need to practice, and to experiment with exposure, to get good results. It is better to underlight slightly than to overlight.

● **Fix the camera** on a tripod or place it on a wall or table.

● **Set the shutter to B** and use a locking cable release to hold the shutter open.

● **Set the flash** on 'manual' and pick an aperture that will render existing lights naturally in an exposure of about a minute. Use the aperture to give you your flash-to-subject distance. For example, the mosque below needed six flashes at about 10 feet.

● **Keep the flash** at a constant distance from the walls. With high ceilings, give extra flashes.

● **Avoid overlap.** Equally, make sure there are no gaps.

● **Take several pictures** at different apertures.

● **Keep out of the picture** and wear dark clothing. If you stand between the camera and the flash, your silhouette will register.

▲ Cordoba's Great Mosque was lit insufficiently, so I used six flashes during an exposure of one minute at ƒ22.

▶ There were heavy shadows in the Gallery of Mirrors, Palazzo Doria Panhili, Rome: I increased detail by adding 12 flashes at ƒ32.

AVOID STEREOTYPES

Any place with a claim to fame has almost certainly been photographed a million times before and is almost certainly overrun with tourists. How do you capture the essential atmosphere of a place without ending up with a stereotype and how do you clear the ground of all those milling hordes?

● **Rise early,** in order to miss the crowds that clutter the scene later in the day.

● **Look** for the characteristics of the place that give it its unique quality and work out how you can express them in your photographs. For example, the mass of a huge reclining Buddha can be made more obvious if a child is included in the picture.

● **Find an unusual angle.** If you look hard enough, you'll always find one point from which you can photograph without people or litter being too obtrusive.

● **Find out** what the scene looks like from various angles. Look at local postcards too: they are usually the stereotyped views. Then search for a viewpoint that catches the scene differently.

● **Search for the detail** that epitomizes the whole. For example, it is almost impossible to find a time when a cathedral like St. Peter's in Rome is free of people, whether devout or sightseers. So turn your camera on to the aspects that illustrate the life of a great religious centre.

▲ The only way to avoid photographing litter in the pool leading to Akbar's tomb at Sikandra was to wait until sunset. Below left, the usual shot of converging New York skyscrapers was avoided by taking a ride in a helicopter and (below) the brightly-garbed tourists who spoil the mystery of Machu Picchu were avoided by shooting before they arrived for the day.

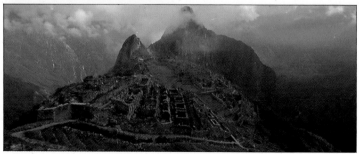

SHOOT THROUGH GLASS

Unless you deliberately seek them for effect, reflections in glass are at best an irritating distraction and at worst can totally obscure the subject behind the glass. You can eliminate them by picking your lens and camera angle — and, where possible, the lighting — with care, and by using a polarizing filter.

● **Pick your angle** so that a dark subject is reflected in the glass — its weak reflections will not show up in the picture.

● **Pick your lighting** so that, if possible, the light on the far side of the glass, where your subject is, is brighter than on the camera side.

● **Use a polarizing filter.** This cuts out reflections from most shiny surfaces. However, a polarizer works well only at certain angles to the surface. The best angle for glass is about 60°

● **Rotate the filter** to determine the best orientation. All polarizers have rotating mounts and must be adjusted to the correct angle.

● **Choose a long lens,** which, with a polarizer, will kill reflections evenly across the frame. A wide angle lens may not destroy them at the edges.

▶ Strong light inside the window helped the picture of the bread; a polarizing filter cut reflections obscuring the girl in the car.

USE REFLECTIONS

Reflections can reveal new aspects of even familiar buildings, forcing the viewer to see them in a different way, and emphasizing features that might otherwise be buried by an overall impression of sheer bulk. Look for them in the glass facades of modern buildings, in stretches of water, and even in street puddles.

● **Find well-lit subjects** and try to keep the reflecting surface in shadow, to maximize reflective qualities. Mirrored glass reflects only when light on the camera side is brighter than light on the other side. You'll get the best results indoors at night and outdoors by day.

● **Pick oblique angles** when photographing reflections in plain glass or water. Head-on views do not give such bright reflections.

● **Throw stones** into still pools to break up reflections of the subject and thus make patterns more abstract.

● **Think small** and catch exciting reflections in small shiny surfaces, such as the hotel sign opposite.

● **Crop tight** using a telephoto lens to catch reflected glimpses of nearby buildings.

▲ I produced a photograph like an oil painting by simply catching the reflection of Blackpool Tower in a puddle of sea water.

▼ Ripples in a glass facade distort the rigid lines of a modern block.

▲ Distant reflections of Rio create a delicate mirror image and a shimmering light.

▲ Shot through the glass door of a small hotel, the picture above combines a sharply mirrored image with a softened interior and reflections from the street outside.

▶ A wet pavement makes an abstract pattern suggesting the colour and excitement of night in a big city.

ALTER HUES

The camera never lies — but it may distort the truth a little, or present facts out of context. This final section of the book shows you how you can use a variety of effects and tricks to make things appear on film as they never did to the eye, beginning with a simple yet remarkably effective technique — that of changing the hues of a subject by using brightly coloured lights.

● **Buy a swatch** of lighting gels from a theatrical lighting shop. Each gel in the swatch is small, but big enough to cover the reflector of a small flash unit. Tungsten lights will need larger squares of gel.

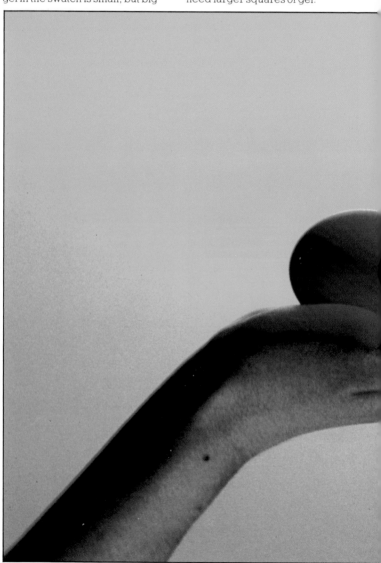

● **Pick strong colours** for the most dramatic effects: with weak colours the result may look like a mistake.

● **Leave space** for ventilation between the gel and the lamp.

● **Don't trust meters** or automatic flash guns. Make exposure tests or bracket your pictures.

● **Experiment** by moving lights around and changing colours. Don't use too many colours. The best images are often very simple — like the one below.

▼ The egg and the girl's hand were lit by a red spotlight, the white screen in the background by a blue light. The mixture produced a white rim around the egg.

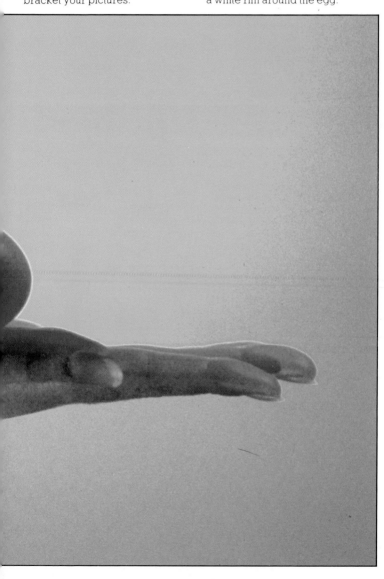

USE FILTERS FOR FANTASY

Filters are probably the cheapest of photographic accessories, yet they can have a greater impact on the appearance of your pictures than a special and expensive lens. Even if you expect to use special effects filters only rarely, it is worth tucking one or two into your camera bag just in case you're faced with a mundane or difficult subject.

● **Use special filters** with discretion or the effect will overpower your subject.

● **Use the pre-view button** to check what the effect of the filter will be. With most it will vary according to the aperture.

● **Keep filters clean.** Dirt or scratches will cause flare. For the same reason, never use more than two filters together.

● **Use filter adapters** with lenses of different sizes.

▼ The binocular effect was created with a mask made from black card, a dual colour filter produced the unusual landscape, and a spot filter was used for the portrait.

▲ Diffraction filters have ribbed surfaces that break light up into the spectrum. They can be used (above) with prism filters to deform the image. Revolving the wheel type (right) during exposure makes bands of colour.

▲ Diffusion filters create a halo effect around bright areas of the subject and produce soft and romantic moods.

▶ Prism filters repeat part of the image on separate facets of the lens attachment to suggest movement or to create patterns or surreal images. Rotating a prism filter to a vertical alignment elongated the girl. Some prism filters have a central hole to give a sharp image.

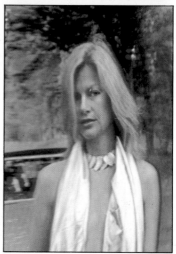

COLOUR MOVING OBJECTS

Colour film has three layers — sensitive to blue, green and red light. By filtering to expose the layers consecutively, rather than simultaneously, you can add brilliant colour to moving objects, while recording static ones in their natural hues.

● **Use negative film,** because colour balance is difficult to control using this technique. With negative film you can correct colour when printing.

● **Buy Wratten filters** as gelatine squares. Use numbers 25 (red), 61 (green) and 38A (blue).

● **Meter the scene** without the filters in place, then allow one extra stop for each exposure.

● **Make three exposures** on one frame, using a different filter each time. See page 140 for multi-exposure techniques.

● **Choose subjects carefully.** Even static subjects can be coloured — provided that the sun is shining and that you allow half an hour or so between exposures. The shifting shadows then create delicate colour fringes.

▼ Red, green and blue filters, used successively in a triple exposure, gave normal colour in most of the picture, but recorded highlights in the inlet separately.

ADD HIGHLIGHT SPARKLE

Starburst and diffraction filters spread highlights across the frame like brilliant bolts of lightning. With them you can make a rainswept, off-season seaside resort throb with energy and excitement or turn a string of paste into real diamonds.

● **Use starburst filters** — often called cross-screen filters — to make plain spikes of light. There is a range of filters, producing 2, 4, 6, 8 and 16 points from each highlight. The simplest filters usually produce the most successful pictures.

● **Use diffraction filters** to put colour into the picture, in addition to creating brilliant rays of light. Diffraction filters split white light into the colours of the spectrum, but have little effect on monochromatic light such as that from sodium streetlights.

● **Find a dark background,** so that the spikes stand out clear and bright.

● **Rotate the filter** during a long exposure to create a halo of light around each light source. With a diffraction filter the action will make a rainbow.

● **Avoid fine detail,** because these filters will soften the picture and reduce sharpness.

▲ A 'vario-starburst' diffraction filter gave the lighthouse beam a more natural appearance than it would have had without the filter.

▼ The repeating images created by a prism filter turn a city street at night into a blaze of colour.

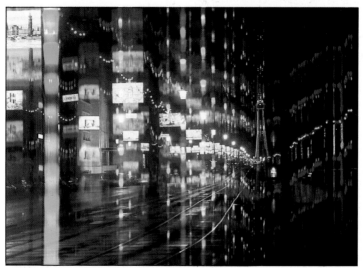

KEEP NEAR AND FAR SHARP

There are occasions when you need to keep everything in a picture sharp, from something only inches from the camera to something that for all practical purposes is at infinity. Even a wide-angle lens stopped down to its smallest aperture may not give you the result you want. The answer is to fit a split-field close-up lens. This, sometimes called a half-lens, is literally that: a semi-circle of magnifying glass which fits over your lens and brings near objects into focus while the main lens focuses farther back.

● **Base your choice** of lens on the distance of the foreground subject. A + 1 lens focuses 1m from the camera, a + 2 lens half a metre away, and so on.

● **Focus** for the distant subject and try to keep a featureless area in the centre of the picture, because the image blurs at the edge of the split field lens.

▼ A half-lens brought the foreground flowers into focus. Note the soft-focus boundary at the lens's edge.

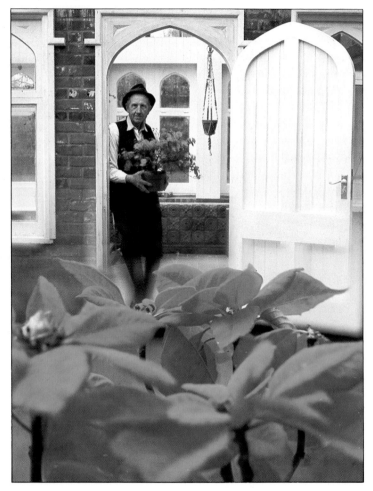

COMPRESS SPACE

Extra-long telephoto lenses allow you to stand a long way· from your subject, but have the effect of compressing space dramatically. Well-separated subjects appear to be on top of one another. To make the most of this characteristic, you need to understand long lenses and to choose subjects that exploit their qualities.

● **Use 200mm** or longer lenses. Shorter lengths don't produce a sufficiently pronounced effect.

● **Juxtapose** near and far in the same picture. If your subject stands alone, the compression will be less obvious.

● **Get similar subjects** into the same frame. Telephoto pictures look dramatic because they make the subjects look the same size in spite of the distance between them.

● **Shoot early** or haze will veil your picture.

▼ Long lenses reduce separation. The lorries, taken from 400yd with an 800mm lens, were in fact well spaced and travelling at 30mph.

EXPLOIT WIDE LENSES

In many photographic applications, the faults and foibles of wide-angle lenses are a hindrance: no one wants converging verticals and bulging walls in a formal architectural picture. However, if your aim is to make an image that excites, rather than a picture that is geometrically and technically perfect, then it may be worth exaggerating the distortions that accompany wide-angle views.

● **Move close** to the subject to maximize distortion. A wide-angle lens permits you to fill the frame from a viewpoint near to the subject and seen from such close proximity, perspective and size relationships are upset.

● **Tilt the camera** to make parallel lines converge steeply as they recede into the distance. Patterned surfaces, such as tiled walls or wooden floorboards, show the effect much more clearly than plain surfaces.

● **Frame off-centre.** Subjects at the corners and edges of the frame are distorted much more by a wide-angle lens than subjects at the centre of the picture. Circular and familiar objects — such as footballs and faces — appear stretched dramatically in the corners of the picture.

● **Use fish-eye lenses** for the ultimate in distortion. Circular image fish-eyes make a round image about 23mm across on the film. Though such lenses produce striking images, the bubble shape is sometimes hard to accommodate on the printed page or on a wall of framed pictures. The full frame fish-eye, which covers the whole of the 35mm format, is perhaps of practical use more often.

● **Save money** by using a wide-angle converter. This screws to the front of the lens and creates ultra-wide views. Another type turns a standard lens into a full frame fish-eye and a 24mm lens into a circular image fish-eye.

▶ An 8mm fish-eye produced the picture bottom opposite; a 15mm wide-angle the distorted head top opposite. A more normal view, but still distorted, was obtained of the boy cyclists by moving in close with a 28mm wide-angle. The lens kept both boys in focus and gave a feeling of immediacy.

8mm fish-eye lens

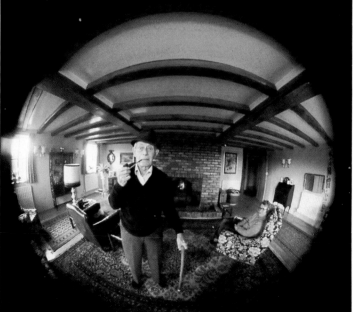

FIND EXOTIC BACKGROUNDS

Professional photographers often use projected backgrounds as substitutes for exotic real-life locations: palm-fringed islands can be created in the studio for a fraction of the cost of a trip to the Caribbean. Although professional front-projection equipment is sophisticated and expensive, you can simulate some of its effects with an ordinary slide projector.

● **Pick a slide** that gives an overall impression of the scene that you want as a background.

● **Match lighting** so that the light on the foreground figure is of the same quality, direction and intensity as the light on the background.

● **Avoid shadows** on the background by keeping the subject well forward from the screen. This will also prevent subject lighting falling on the screen.

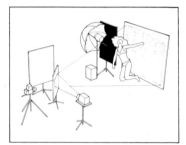

▲ The street scene was bounced off semi-transparent glass and the camera aligned so that the model masked her own shadow.

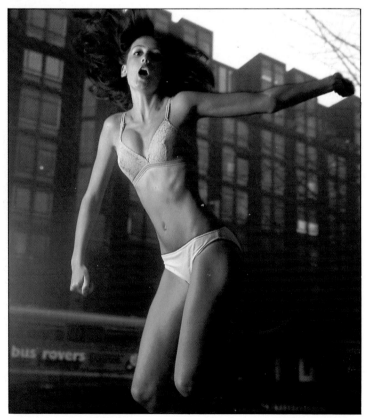

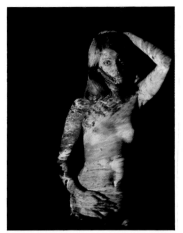

● **Match colour** of foreground and background by shooting a test roll of film. Filter if necessary.

● **Use tungsten film** and floodlamps to match the projector's tungsten lamp.

● **Use angled glass** with the camera behind it to produce a true front-projection. Otherwise, try to keep projector and camera as close together as possible.

● **Experiment** by projecting images onto your model.

▲ An abstract pattern projected onto the model produced this effect.

◄ A professional front-projection unit was used for this shot. Studio lamps lit the model.

MIRROR IMAGES

A pool of water reflects light and colour like a mirror in constant motion. The slightest breeze or vibration changes the reflection, making a new, abstract pattern. This is particularly true of those modern building complexes in which a pool or a fountain reflects the geometric lines of today's design, but, when its surface is disturbed, gives them a gentler expression.

● **Explore different angles** and make use of brightly coloured subjects.

● **Use a 90-135mm lens** to select abstract areas.

● **Try double exposure** to combine different reflections and straightforward shots.

● **Shatter the image** by blowing on the water's surface.

● **Use slow shutter speeds** to express the movement.

▼ A weathered boathouse, reflected in a river, gains the quality of tapestry from faint ripples.

CREATE DISTORTIONS

The flowing, changing surface of a pool of water may add variety and randomness to your reflection photographs, but it is hardly conducive to repeatability. If you want to be more in control of the scene that you are photographing, you should look for a more permanent reflective medium. Those available range from foil, which is cheap, to reflective acrylic sheet, which is not.

● **Pick reflectors** that have some rigidity of their own. Foil-covered card, tin sheets and reflective acrylic sheet can all be easily bent or flexed.

● **Stretch thin films** such as reflective sheet over timber frames. Heat the sheet before stapling it to the frame so that when it cools it becomes taut. Press from behind to distort the normal reflection.

● **Use the viewfinder** to monitor progress as you build up the distorted image. From other angles the reflections will look quite different.

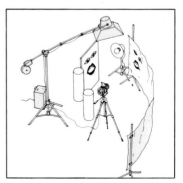

▲ Features stuck on a glazing sheet were distorted in a flexible plastic mirror and reflections added by foil cylinders.

USE INFRARED FILM

Like ordinary colour film, infrared film has three layers, but because one of these layers is sensitive not to visible light but to infrared radiation, the film creates a bizarre world of distorted hues and brilliant colours. Foliage turns out brilliant pink and flesh tones an unearthly green.

● **Use a yellow filter,** because infrared colour film is sensitive to blue light, which creates a heavy colour cast. A Kodak Wratten 12 filter is a good choice.

● **Refrigerate the film** until you are about to use it. Heat can cause fogging.

● **Set your meter** to ISO 100 and take readings without the filter. Bracket exposures because your camera's TTL meter will not read the IR element in the light.

● **Focus normally** — the infrared focusing mark on your lens barrel is designed for use with black and white IR film.

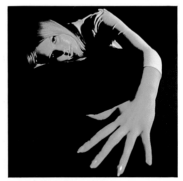

▲ Infrared film and two exposures, the second with a red filter, produced the bizarre portrait; the same film shot in natural light turned foliage pink.

MAKE HIDDEN SUPPORTS

The camera sees the world around us from just one angle. By taking advantage of this limitation, you can produce trick photographs that confuse the viewer and demand attention. The trick lies in hiding the supporting structure.

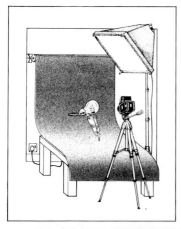

● **Pick subjects** that look unnatural when floating in air.

● **Suggest** gravity has failed by supporting heavy subjects from below, against a plain background, and then shooting them from above. The viewer will assume that the camera was horizontal.

● **Light carefully.** Remember that light usually comes from above — the top of the picture.

◀ A support soldered to the bulb's base, electric wires soldered to the terminals, and a pin through the feather created this illusion.

DOUBLE EXPOSE

Multiple exposure is one of the most versatile of all special effects. Using it, you can combine several quite different picture elements within one frame.

● **Read the instructions** supplied with your camera. It may have a special multi-exposure feature fitted, which will make double exposures much easier. If not, follow these steps.

● **Make the first exposure** — you may have to underexpose, as explained below.

● **Tension the film** across the camera back by turning the film rewind knob until you have taken up the slack in the cassette. Then hold the crank in place.

● **Press the rewind button,** which is usually on the camera's base plate.

● **Crank the lever wind.** This will tension the shutter without advancing the film.

● **Make** the second exposure, possibly underexposing as before.

● **Cut exposure** when laying an image on top of a similar one. For two images cut by one stop; for four, cut by two stops; for eight, cut by three stops; and so on.

▲ The eye was cut from a magazine. I photographed it with a Hasselblad, marking the position of the bottom of the eyelid on the camera screen and underexposing by half a stop. Then, with the girl against a black backdrop, I positioned her in the lower half of the viewfinder and re-exposed the frame.

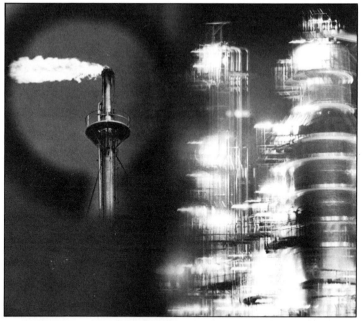

▼ I took the girl, who was in black clothes against a black backdrop, through a double-exposure filter and then rotated the filter 180° to add her hands and feet.

▲ To take this picture I used a plate camera, which let me double-expose one half of the negative while giving the other half only one exposure. The jet of flame is seen through a tube of rolled metal foil, held in front of one side of the lens. The first exposure thus recorded both the refinery and the flame. During the second exposure, I slid the sheath across half the frame to cover the jet and gently tapped the tripod so that vibration produced a double-exposed image of the refinery that seems to quiver with power.

COMBINE IMAGES ON SLIDE

Multiple exposure is not the only way to combine images: you can also sandwich together slides or negatives to overlay one frame on another. This technique has the advantage that you can produce multiple images from your existing file of photographs.

● **Pick thin slides,** because sandwiching is additive: if you combine pictures of normal density the resulting sandwich will be too dark.

● **Clean each slide** very thoroughly. Remember that you are doubling the number of surfaces on which dust can collect.

● **Align the images** on a lightbox. If you don't have one, tape a piece of tracing paper to a window and use this to illuminate the slides from behind.

● **Tape the frames** together so

that they cannot move out of alignment. Slide mounts alone will not keep pictures in register.

▼To check if slides are suitable for combining, remove them from their mounts, tape them together, remount them and then project them. The picture of the parachutist framed in the sun's disc would have been difficult to obtain without this technique. The parachutist was shot with a 135mm lens on a dull day; the sun at sunset through a misty atmosphere with a 200mm lens. This second transparency was then enlarged.

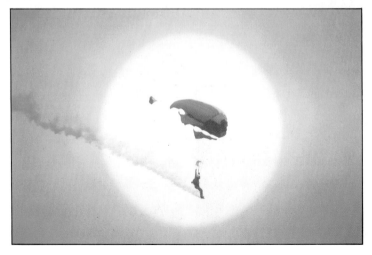

MULTIPLY THE IMAGE

A multi-image prism lens is a quick and convenient way to inject movement into static or lacklustre subjects. The lens screws into the front of your main lens just like a filter and its facetted surface split the subject into several identical images.

● **Pick dark backgrounds** and bright subjects. That way, the images that surround the main subject will stand out clearly.

● **Try different lenses** to alter the spacing of the multiple images on the frame.

● **Stop down the lens,** as these prisms can reduce contrast and

definition in the final result.

● **Shade the lens** from direct light, as the extra glass surface can cause flare. Make sure, though, that the shading does not appear in the picture.

● **Colour the facets** of the prism with a felt-tipped pen. This will colour the individual images.

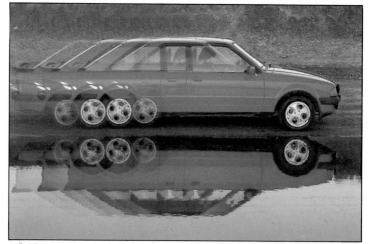

▲ A 4-band prism lens added an impression of movement to a parked car; 3-band lenses added interest to the portrait and the shot of County Hall, London. Prism lenses are available to repeat an image 3, 4, 5 or 6 times.

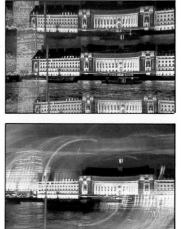

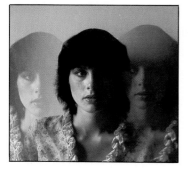

COPY IMAGES

Copying photographs is a straightforward, almost mechanical process, yet it has a fundamental importance in many special effects techniques. For example, when you've created a photomontage from several images, you can copy the result to make a seamless print. The same technique can be used to copy paintings, drawn artwork, and even solid objects like coins or badges.

● **Use a tripod** and cable release to hold the camera steady. Alternatively, for small subjects, use a copy stand.

● **Make lighting even,** by arranging a lamp on either side of the subject to be copied. Even two small electronic flash units will do, though tungsten lamps are easier to use. Check lighting balance by measuring the distance from each lamp to the middle of the subject or by standing a pencil up in the centre of the subject — the shadows on each side should be equally dark and the same length.

● **Load slow film,** such as Kodachrome 25, Kodacolor 100, or Ilford FP4.

● **Eliminate reflections,** both of the lights and the camera, or

they will appear in the picture. Cover the camera with black velvet — cut a hole for the lens. Reflections of the lights can usually be eliminated by repositioning them on either side of the subject being copied.

● **Set exposure** by covering the subject with a Kodak Neutral Gray card, then use your TTL meter. This prevents subject tones from influencing the reading. As a makeshift alternative, take a reading from the dull side of a sheet of brown wrapping paper. Bracket pictures to be sure of good results.

● **Use a standard lens** or a macro lens. These will give sharper pictures than lenses of other focal lengths. Stop the lens down to *f*8 or a smaller aperture.

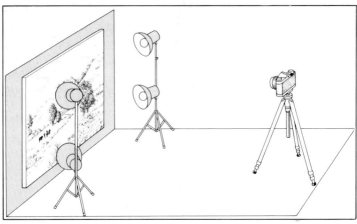

▲ To light a large subject evenly, use four lamps, aiming each at a corner of the subject. They should be about one or two metres from the subject and at an angle of about 45° to its surface. The camera should be placed some distance away in order to avoid flare.

▲ To copy drawings, engravings and stamps, use a cross-arm tripod. To check alignment, put a mirror flat on the original and adjust the camera until a reflection of the lens is in the centre of the viewfinder. If you are working with tungsten lamps, angle them down at 45°. For engravings or drawings, use line or lith film. For continuous-tone originals, use slow, normal-contrast film.

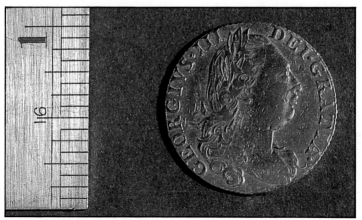

▲ Photograph a coin by placing it on a contrasting or black background and position the camera above using a tripod or copying stand. To bring out the relief of the original, illuminate it with a spotlight placed a yard or so away and pointing down at about 30° to the copyboard. Fit a lens hood to eliminate flare or reflections. To bring out surface detail, front or oblique lighting is needed. This can be obtained with a ring flash or a glass sheet and a spotlight. Use a clamp to fix the glass at 45° between the camera and the subject. Place the light about a yard away.

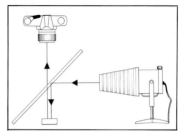

CONTROL TONES

Coloured filters have special value when used with black and white film. They lighten those parts of the subject that are the same colour as the filter and darken complementary colours. So by picking your filter, you can control precisely the tones that, in a black and white print, represent the colours of the spectrum.

● **Use an ultraviolet** filter to cut down haze and to protect the lens.

● **Use yellow filters** to darken blue sky slightly, to render the tones of stone, fabric and sand accurately, and to lighten foliage a little.

● **Use orange filters** to produce more pronounced effects than yellow filters.

● **Use red filters** for really dramatic effects — blue sky becomes almost black.

● **Use blue filters** to exaggerate haze and mist.

● **Filter portraits** to control skin tones. A red filter will hide skin blemishes; a green filter will make a pale-skinned person look healthy and weather-beaten. A yellow filter is useful indoors.

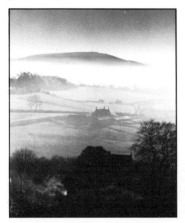

▲ Ultraviolet filters cut haze.

▲ Red filters darken skies.

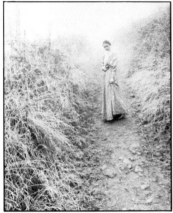

▲ Green filters lighten foliage.

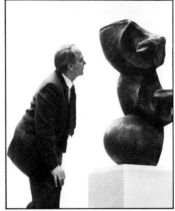

▲ Yellow filters give natural tones.

EXAGGERATE GRAIN

Photograhers usually regard grain as a bugbear — something to be avoided at all costs. This need not be so. You can use grain creatively, to give your prints a pronounced surface texture or to suggest an atmosphere of gritty realism.

● **Make grain prominent** in these ways:

● **Use fast film,** which has inherently large grain. Tri-X is a good choice.

● **Overexpose the film** a little. Rate Tri-X at 200 ISO instead of its normal 400.

● **Overdevelop the film** by leaving it in the developer for twice as long as usual. Continuous rather than intermittent agitation will also help.

● **Make big enlargements** from a portion of the negative. Print on glossy paper in a hard grade to get extra contrast.

▼ Accentuated grain enhances the appeal of this picture.

MAKE PHOTO MONTAGES

The cut-and-paste simplicity of photomontage may seem primitive when compared with more technological and sophisticated special effects, but it would be a mistake to underestimate the potential of the technique for making creative statements.

● **Use imagination** in choosing suitable combinations of subjects. Don't be bound by convention: the most surreal and bizarre juxtapositions are often the most exciting.

● **Match prints** for density, contrast and lighting or the joins will be obvious.

● **Plan** where you want each element to fall, using a sheet of tracing paper.

● **Cut the pictures** two-thirds through from the back, then tear them: the result is a ready-bevelled edge that pastes down easily and evenly.

● **Bevel the cut edges** with very fine sandpaper so that the images blend smoothly.

● **Paste the pictures down** onto a stout piece of cardboard using rubber cement. Make sure that no glue remains around the joins.

● **Rephotograph the image** for best results (see page 144).

▲ Seven straight prints and then seven more with the negative reversed produced this portrait.

◄ The man in the bowler hat on the opposite page required 160 separate printings of the same image. The car and the architectural features also had to be printed the required number of times. All the images were mounted and reshot.

▼ A lifesized print of a section of the sphere, glued to the fork, and a piece of black card, glued to the sphere, are the keys to this montage.

▲ To make this portrait I cut a portrait up into strips and then glued them onto a tin spiral. I then rephotographed the result with a hand holding the spiral.

TAKE PICTURES OFF TV

Television provides a virtually limitless number of marvellous images, each subtly different from its predecessor and its successor. On location in your living room, you can make a permanent record of the history of our times. Remember, though, that television is protected by copyright laws.

● **Use a tripod** to lock your camera rigidly in position in front of the centre of the screen.

● **Cut the colour** intensity of the screen image to a little lower than normal.

● **Draw the curtains** and turn out the room lights to eliminate reflections.

● **Take a meter reading** close to the screen or use automatic.

● **Set the shutter** to 1/15 or slower to enable each picture scan to be completed: faster speeds will record a dark band across the image.

● **Use your video recorder** to freeze-frame fast moving action and photograph the still image.

▲ TV provides almost every kind of image. If you are using daylight colour film, try fitting a Kodak CC40R filter to cut any blue-green cast, or, alternatively, make the colour on the set a little redder. You will find that simple images, such as the cartoon above, offer scope for later montage work.

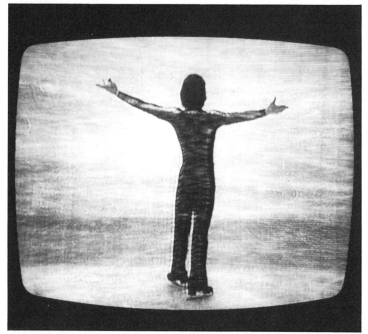

PHOTOGRAPH SCALE MODELS

In the film industry elaborate scale models are used to reconstruct history, envisage the future, or save costs. Model making at that level is a highly skilled craft, but by adapting some of the movie makers' tricks and techniques, you can create similar effects on top of a kitchen table.

● **Make a model** with photography in mind. Since the camera sees only one side of a model, you need only build one side. Detail can be cruder if the camera is going to be some distance away.

● **Build backgrounds** in scale. Sand is too coarse in close up — use Fuller's earth, flour or cement to simulate earth. Stars can be put in behind space models by pricking holes in a sheet of black card and backlighting it.

● **Arrange the lighting** to look as realistic as possible. Use a flashgun from a distance to simulate the sun.

● **Pick viewpoint carefully.** The camera needs to be at 'ground level' and usually close to the subject. Use a wide angle lens and stop down as far as possible.

● **Create** aerial perspective by blowing smoke across the scene.

▲ Careful but inexpensive model making lay behind the 'bridge between the worlds' below. Polystyrene spheres served as the two planets; the bridge was made of cardboard cut to give the effect of diminishing perspective. The spheres and the bridge were mounted in front of a sheet of black backdrop paper, pricked with holes and backlit to give the effect of stars; and a model of Saturn was hung from a boom between the backdrop and the model.

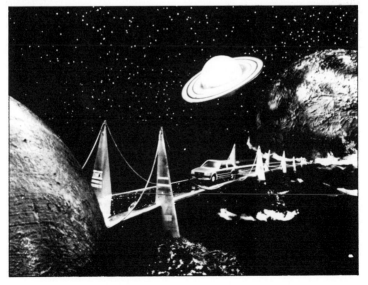

GLOSSARY

Aberration. Inherent faults in a lens image. Aberrations include ASTIGMATISM, BARREL DISTORTION, CHROMATIC ABERRATION, COMA, SPHERICAL ABERRATION. COMPOUND LENSES minimize aberrations.

Accelerator. Alkali in a developer, used to speed up its action.

Actinic. (Describing light) able to affect photographic material. With ordinary film, visible light and some ultraviolet light is actinic, while infra-red is not.

Air bells. Bubbles of air clinging to the emulsion surface during processing, which prevent uniform chemical action. Removed by agitation.

Airbrush. An instrument used by photographers for retouching prints. It uses a controlled flow of compressed air to spray paint or dye.

Anamorphic lens. Special type of lens which compresses the image in one dimension by means of cylindrical or prismatic elements. The image can be restored to normal by using a similar lens for printing or projection.

Angle of view. Strictly the angle subtended by the diagonal of the film at the rear NODAL POINT of the lens. Generally taken to mean the wider angle 'seen' by a given lens. The longer the focal length of a lens, the narrower its angle of view. See also COVERING POWER.

Aperture. Strictly, the opening that limits the amount of light reaching the film and hence the brightness of the image. In some cameras the aperture is of a fixed size; in others it is in the form of an opening in a barrier called the DIAPHRAGM and can be varied in size. (An iris diaphragm forms a continuously variable opening, while a stop plate has a number of holes of varying sizes.) Photographers, however, generally use the term 'aperture' to refer to the diameter of this opening. See also F NUMBER.

ASA. American Standards Association, which devised one of the two most commonly used systems for rating the speed of an emulsion (i.e., its sensitivity). A film rated at 400 ASA would be twice as fast as one rated at 200 ASA and four times as fast as one rated at 100 ASA. See also DIN, ISO.

Astigmatism. The inability of a lens to focus vertical and horizontal lines in the same focal plane. Corrected lenses are called 'anastigmatic'.

Automatic camera. Camera in which the exposure is automatically selected. A semi-automatic camera requires the user to pre-select the shutter speed or the aperture.

Back projection. Projection of slides on to a translucent screen from behind, instead of onto the front of, a reflective screen.

Ball-and-socket head. A type of tripod fitting that allows the camera to be secured at the required angle by fastening a single locking-screw. See also PAN-AND-TILT HEAD.

Barn doors. Hinged flaps for studio lamps, used to control the beam of light.

Barrel distortion. Lens defect characterized by the distortion of straight lines at the edges of an image so that they curve inwards at the corners of the frame.

Bas relief. In photography the name given to the special effect created when a negative and positive are sandwiched together and printed slightly out of register. The resulting picture gives the impression of being carved in low relief, like a bas-relief sculpture.

Beaded screen. Type of front-projection screen. The surface of the screen is covered with minute glass beads, giving a brighter picture than a plain white screen.

Bellows. Light-tight folding bag made of pleated cloth used on some cameras to join the lens to the camera body.

Between-the-lens shutter. One of the two main types of shutter. Situated close to the diaphragm, it consists of thin metal blades or leaves which spring open and then close when the camera

is fired, exposing the film. See also
FOCAL PLANE SHUTTER.

Bleaching. Chemical process for removing black metallic silver from the emulsion by converting it to a compound that may be dissolved.

Bloom. Thin coating of metallic fluoride on the air-glass surface of a lens. It reduces reflections at that surface.

Bounced flash. Soft light achieved by aiming flash at a wall or ceiling to avoid the harsh shadows that result if the light is pointed directly at the subject.

Bracketing. Technique of ensuring perfect exposure by taking several photographs of the same subject at slightly different settings.

Bromide paper. Photographic paper for printing enlargements. The basic light-sensitive ingredient in the emulsion is silver bromide.

B setting. Setting of the shutter speed dial of a camera at which the shutter remains open for as long as the release button is held down, allowing longer exposures than the preset speeds on the camera. The 'B' stands for 'brief' or 'bulb' (for historical reasons). See also T SETTING.

BSI. British Standards Institution, which has an independent system of rating emulsion speed, similar to the ASA system. However, the BSI system is used industrially rather than by photographers.

Bulk loader. Device for handling film which has been bought in a bulk as a single length and which needs to be cut and loaded into cassettes. A loader will hold up to about 30m (100ft) of film.

Burning in. Technique used in printing photographs when a small area of the print requires more exposure than the rest. After normal exposure the main area is shielded with a card or by the hands while the detail (e.g., a highlight which is too dense on the negative) receives further exposure. See also DODGING.

Cable release. Simple camera accessory used to reduce camera vibrations when the shutter is released, particularly when the camera is supported by a tripod and a relatively long exposure is being used. It consists of a short length of thin cable attached at one end to the release button of the camera; the cable is encased in a flexible rubber or metal tube and is operated by a plunger.

Callier effect. Phenomenon which accounts for the higher contrast produced by enlargers using a condenser system as compared with those using a diffuser system. This effect, first investigated by André Callier in 1909, is explained by the fact that the light, focused by the condenser onto the lens of the enlarger, is part!y scattered before it reaches the negative before it reaches the lens; and because the denser parts of the negative scatter the most light, the contrast is increased. In a diffuser enlarger, on the other hand, all areas of the negative cause the same amount of scattering.

Calotype. Print made by an early photographic process using paper negatives. Iodized paper requiring lengthy exposure was used in the camera. The system was patented by Fox Talbot in 1841, but became obsolete with the introduction of the COLLODION PROCESS. Also known as Talbotype.

Camera movements. Adjustments to the relative positions of the lens and the film whereby the geometry of the image can be controlled. A full range of movements is a particular feature of view cameras, though a few smaller cameras allow limited movements, and special lenses are available which do the same for 35mm cameras.

Camera obscura. Literally a 'dark chamber'. An optical system, familiar before the advent of photographic materials, using a pinhole or a lens to project an image onto a screen. One form of camera obscura, designed as an artists' aid, is the ancestor of the modern camera.

Canada balsam. Resin used to cement together pieces of optical glass, such as elements of a lens. When set it has a

refractive index almost exactly equal to that of glass. It is obtained from the balsam fir of North America.

Cartridge. Plastic container of film, either 126 or 110. The film is wound from one spool to a second spool inside the cartridge.

Cassette. Container for 35mm film. After exposure the film is wound back onto the spool of the cassette before the camera is opened.

Cast. Overall shift towards a particular hue, giving colour photographs an unnatural appearance.

CdS cell. Photosensitive cell used in one type of light meter, incorporating a cadmium sulphide resistor, which regulates an electric current. See also SELENIUM CELL.

Centre-weighted meter. Type of through-the-lens light meter. The reading is most strongly influenced by the intensity of light at the centre of the image.

Chromatic aberration. The inability of a lens to focus different colours on the same focal plane.

Circle of confusion. Disc of light in the image produced by a lens when a point on the subject is not perfectly brought into focus. The eye cannot distinguish between a very small circle of confusion (of diameter less than 0.01in) and a true point.

Close-up lens. Simple positive lens placed over the normal lens to magnify the image. The strength of the close-up lens is measured in diopters. Also known as SUPPLEMENTARY LENS.

Cold cathode enlarger. Type of enlarger using as its light source a special fluorescent tube with a low working temperature. Its uniform illumination is particularly suitable for large-format work.

Collodion process. Wet-plate photographic process introduced in 1851 by F. Scott Archer, remaining in use until the 1880s. It superseded the DAGUERREOTYPE and CALOTYPE processes.

Colour analyser. Electronic device which assesses the correct filtration for a colour print.

Colour conversion filters. Camera filters required when daylight colour film is used in artificial light, or when film balanced for artificial light is used in daylight.

Colour correction filters. Filters used to correct slight irregularities in specific light sources (e.g., electronic flash). The name is also used to describe the cyan, magenta and yellow filters which are used to balance the colour of prints made from colour negatives.

Colour negative film. Film giving colour negatives intended for printing.

Colour reversal film. Film giving colour positives (i.e., slides or transparencies) directly. Prints can also be made from the positive transparencies.

Colour temperature. Measure of the relative blueness or redness of a light source, expressed in KELVINS. The colour temperature is the temperature to which a theoretical 'black body' would have to be heated to give out light of the same colour.

Coma. A lens defect which results in off-axis points of light appearing in the image not as points but as discs with comet-like tails.

Compound lens. Lens consisting of more than one element, designed so that the faults of the various elements largely cancel each other out.

Condenser. Optical system consisting of one or two plano-convex lenses (flat on one side, curved outwards on the other) used in an enlarger or side projector to concentrate light from a source and focus it onto the negative or slide.

Contact print. Print which is the same size as the negative, made by sandwiching together the negative and the photographic paper when making the print.

Converging lens. Any lens that is thicker in the middle than at the edges.

The name derives from the ability of such lenses to cause parallel light to converge on to a point of focus, giving an image. Also known as a positive lens. See also DIVERGING LENS.

Converging verticals. Distorted appearance of vertical lines in the image, produced when the camera is tilted upwards; tall objects such as buildings appear to be leaning backward. Can be partially corrected at the printing stage, or by the use of CAMERA MOVEMENTS.

Converter. Auxiliary lens, usually fitted between the camera body and the principal lens, giving a combined focal length that is greater than that of the principal lens alone. Most converters increase focal length by a factor of two or three.

Convertible lens. Compound lens consisting of two lens assemblies which are used separately or together. The two sections are usually of differing focal lengths, giving three possible permutations.

Correction filter. Coloured filter used over the camera lens to modify the tonal balance of a black and white image; the same term is also used for COLOUR CORRECTION FILTERS.

Covering power. The largest image area of acceptable quality that a given lens produces. The covering power of a lens is normally only slightly greater than the standard negative size for which it is intended, except in the case of a lens designed for use on a camera with movements (see CAMERA MOVEMENTS), when the covering power must be considerably greater.

Cropping. Enlarging only a selected portion of the negative.

Daguerreotype. Early photographic picture made on a copper plate coated with polished silver and sensitized with silver iodide. The image was developed using mercury vapour, giving a direct positive. The process was introduced by Louis Daguerre in 1839, and was the first to be commercially successful.

Daylight film. Colour film balanced to give accurate colour rendering in average daylight, that is to say, when the COLOUR TEMPERATURE of the light source is around 6500 Kelvins. Also suitable for use with electronic flash and blue flashbulbs.

Density. The light-absorbing power of a photographic image. A logarithmic scale is used in measurements: 50 per cent absorption is expressed as 0.3, 100 per cent is 1.0, etc. In general terms, density is simply the opaqueness of a negative or the blackness of a print.

Depth of field. Zone of acceptable sharpness extending in front of and behind the point on the subject which is exactly focused by the lens.

Depth of focus. Very narrow zone on the image side of the lens within which slight variations in the position of the film will make no appreciable difference to the focusing of the image.

Developer. Chemical agent which converts the LATENT IMAGE into a visible image.

Diaphragm. System of adjustable metal blades forming a roughly circular opening of variable diameter, used to control the APERTURE of a lens.

Diapositive. Alternative name for TRANSPARENCY.

Dichroic fog. Processing fault characterized by a stain of reddish and greenish colours — hence the name 'dichroic' (literally, 'two-coloured'). Caused by the use of exhausted FIXER whose acidity is insufficient to halt the development entirely. A fine deposit of silver is formed which appears reddish by transmitted light and greenish by reflected light.

Differential focusing. Technique involving the use of shallow DEPTH OF FIELD to enhance the illusion of depth and solidity in a photograph.

Diffraction. Phenomenon occurring when light passes close to the edge of an opaque body or through a narrow aperture. The light is slightly deflected, setting up interference patterns which may sometimes be seen by the naked

eye as fuzziness. The effect is occasionally noticeable in photography, as when, for example, a very small lens aperture is used.

DIN. Deutsche Industrie Norm, the German standards association, which devised one of the two widely used systems for rating the speed of an emulsion (see also ASA). On the DIN scale, every increase of 3 indicates that the sensitivity of the emulsion has doubled. 21 DIN is equivalent to 100 ASA. See also ISO.

Diverging lens. Any lens that is thicker at the edges than in the middle. Such lenses cause parallel rays of light to diverge, forming an image on the same side of the lens as the subject.

D-max. The maximum density of which an emulsion is capable.

Dodging. Technique, also known as shading, used in printing photographs when one area of the print requires less exposure than the rest. A hand or a sheet of card is used to prevent the selected area receiving the full exposure. See also BURNING IN.

Drift-by technique. Processing technique used to allow for the cooling of a chemical bath (normally the developer) during the time it is in contact with the emulsion. Before use, the solution is warmed to a point slightly above the required temperature, so that while it is being used it cools to a temperature slightly below, but still within the margin of safety.

Drying marks. Blemishes on the emulsion resulting from uneven drying; also, residue on the film after water from the wash has evaporated.

Dry mounting. Method of mounting prints onto card backing, using a special heat-sensitive adhesive tissue.

Dye coupler. Chemical responsible for producing the appropriate coloured dyes during the development of a colour photograph. Dye couplers may be incorporated in the emulsion; or they may be part of the developer.

Electronic flash. Type of flashgun which uses the flash of light produced by a high-voltage electrical discharge between two electrodes in a gas-filled tube. See also FLASHBULB.

Emulsion. In photography, the light-sensitive layer of a photographic material. The emulsion consists essentially of SILVER HALIDE crystals suspended in GELATIN.

Enlargement. Photographic print larger than the original image on the film. See also CONTACT PRINT.

Exposure. Total amount of light allowed to reach the light-sensitive material during the formation of the LATENT IMAGE. The exposure is dependent on the brightness of the image, the camera APERTURE and on the length of time for which the photographic material is exposed.

Exposure meter. Instrument for measuring the intensity of light so as to determine the correct SHUTTER and APERTURE settings. The basic principle is that of light energizing a photosensitive cell to produce a current that actuates a pointer or LEDs.

Extension tubes. Accessories used in close-up photography, consisting of metal tubes that can be fitted between the lens and the camera body, thus increasing the lens-to-film distance.

Farmer's reducer. Solution of potassium ferricyanide and sodium thiosulphate, used in photography to bleach negatives and prints.

Fast lens. Lens of wide maximum aperture, relative to its focal length. The current state of lens design and manufacture determines the standards by which a lens is considered 'fast' for its focal length.

Fill-in. Additional lighting used to supplement the principal light source and brighten shadows.

Film speed. A film's degree of sensitivity to light. Usually expressed as a rating on the ISO, ASA or the DIN scales.

Filter. Transparent sheet, usually of glass or gelatin, used to block a specific part of the light passing through it, or to change or distort the image in some way. See also COLOUR CONVERSION FILTERS, COLOUR CORRECTION FILTERS, CORRECTION FILTERS and POLARIZING FILTERS.

Fisheye lens. Extreme wide-angle lens, with an ANGLE OF VIEW of about 180°. Since its DEPTH OF FIELD is almost infinite, there is no need for any focusing, but it produces images that are highly distorted.

Fixed-focus lens. Lens permanently focused as a fixed point, usually at the hyperfocal distance. Most cheap cameras use this system, giving sharp pictures from about 7ft (2 metres) to infinity.

Fixer. Chemical bath needed to fix the photographic image permanently after it has been developed. The fixer stabilizes the emulsion by converting the undeveloped SILVER HALIDES into water-soluble compounds, which can then be dissolved out.

Flare. Light reflected inside the camera or between the elements of the lens, giving rise to irregular marks on the negative and degrading the quality of the image. It is to some extent overcome by using bloomed lenses (see BLOOM).

Flashbulb. Expendable bulb with a filament of metal foil which is designed to burn up very rapidly giving a brief, intense flare of light, sufficiently bright to allow a photograph to be taken. Most flashbulbs have a light blue plastic coating, which gives the flash a COLOUR TEMPERATURE close to that of daylight. Except in simple cameras, flashbulbs are now being superseded by electronic flashguns, some of them automatic.

Floodlight. General term for artificial light source which provides a constant and continuous output of light, suitable for studio photography or similar work. Usually consists of a 125-500W tungsten-filament lamp mounted in a reflector.

F-number. Number resulting when the focal length of a lens is divided by the diameter of the aperture. A sequence of f-numbers, marked on the ring or dial which controls the diaphragm, is used to calibrate the aperture in regular steps (known as STOPS) between its smallest and largest settings. The f-numbers generally follow a standard sequence such that the interval between one stop and the next represents a halving or doubling in the image brightness. As f-numbers represent fractions, the numbers become progressively higher as the aperture is reduced.

Focal length. Distance between the optical centre of a lens and the point at which rays of light parallel to the optical axis are brought to a focus. In general, the greater the focal length of a lens, the smaller its ANGLE OF VIEW.

Focal plane. Plane on which a given subject is brought to a sharp focus; In practical terms, the plane where the film is positioned.

Focal-plane shutter. One of the two main types of shutter, used almost universally in SINGLE-LENS REFLEX CAMERAS. Positioned behind the lens (though in fact slightly in front of the focal plane) the shutter consists of a system of cloth blinds or metal blades; when the camera is fired, a slit travels across the image area either vertically or horizontally. The width and speed of travel of the slit determine exposure.

Forced development. Technique used to increase the effective speed of a film by extending its normal development time. Also known as 'pushing' the film. The price paid for the increased density is greater graininess and the risk of a high fog level.

Format. Dimensions of the image recorded on film by a given type of camera. The term may also refer to the dimensions of a print.

Fresnel lens. Lens whose surface consists of a series of concentric circular 'steps', each of which is shaped like part of the surface of a convex lens. Fresnel lenses are often used in the viewing screens of SLR cameras.

Gelatin. Colloid material used as binding medium for the emulsion of photographic paper and film; also used in some types of filter.

Glazing. Process by which glossy prints can be given a shiny finish by being dried in contact with a hot drum or plate of chromium or steel.

Grain. Granular texture appearing to some degree in all processed photographic materials. In black and white photographs the grains are minute particles of black metallic silver which constitute the dark areas of a photograph. In colour photographs the silver has been removed chemically, but tiny blotches of dye retain the appearance of graininess. Grain usually increases with film speed. It can be used for arresting pictorial effects.

Granularity. Objective measure of graininess.

Guide number. Number indicating the effective power of a flash unit. For a given film speed, the guide number divided by the distance between the flash and the subject gives the appropriate F NUMBER to use.

Halation. Phenomenon characterized by halo-like band around the developed image of a bright light source. Caused by internal reflection of light from the support of the emulsion (i.e., the paper of the print or the base layer of a film).

Half-frame. Film format measuring 24x18mm, half the size of standard format 35mm pictures.

Halogens. A particular group of chemical elements, among which chlorine, bromine and iodine are included. These elements are important in photography because their compounds with silver (SILVER HALIDES) form the light-sensitive substances in all photographic materials.

Hardener. Chemical used to strengthen the gelatin of an emulsion against physical damage.

High-key. Containing predominantly

light tones. See also LOW-KEY.

Highlights. Brightest area of the subject, or corresponding areas of an image; in the negative these are areas of greatest density.

Holography. Technique whereby information is recorded on a photographic plate as an interference pattern which, when viewed under the appropriate conditions, yields a three-dimensional image. Holography bears little relation to conventional photography except in its use of a light-sensitive film.

Hot-shoe. Accessory shoe on a camera which incorporates a live contact for firing a flashgun, thus eliminating the need for a separate contact.

Hue. The quality that distinguishes between colours of the same saturation and brightness; the quality, for example, of redness or greenness.

Incident light. Light falling on the subject. When a subject is being photographed, readings may be taken of the incident light instead of the reflected light.

Infrared radiation. Part of the spectrum of electromagnetic radiation, having wavelengths longer than visible red light (approximately 700 to 15,000 nanometres). Infrared radiation is felt as heat, and can be recorded on special types of photographic film. See IR SETTING.

Integral tripack. Composite photographic emulsion used in virtually all colour films and papers, comprising three layers, each of which is sensitized to one of the three primary colours.

Intermittency effect. Phenomenon observed when an emulsion is given a series of brief exposures. The density of the image thus produced is lower than the image density produced by a single exposure of duration equal to the total of the short exposures.

Inverse square law. Law stating that, for a point source of light, the intensity of light decreases with the square of the

distance from the source, thus, when the distance is doubled, the intensity is reduced by a factor of four.

IR (infrared) setting. A mark sometimes found on the focusing ring of a camera, indicating a shift in focus needed for infrared photography.

Irradiation. Internal scattering of light inside photographic emulsions during exposure, caused by reflections from the SILVER HALIDE crystals.

ISO (International Standards Organisation). System of rating emulsion speeds which is replacing ASA and DIN.

Joule. Unit of energy in the SI (Système International) system of units. The joule is used in photography to indicate the output of an electronic flash.

Kelvin (K). Unit of temperature in the SI system of units. The Kelvin scale begins at absolute zero (– 273°C) and uses degrees equal in magnitude to 1°C. Kelvins are used in photography to express COLOUR TEMPERATURE.

Laser. Acronym for Light Amplification by Stimulated Emission of Radiation. Devide for producing an intense beam of coherent light that is of a single very pure colour. See also HOLOGRAPHY.

Latensification. Technique used to increase effective film speed by fogging the film, either chemically or with light, between exposure and development.

Latent image. Invisible image recorded on photographic emulsion as a result of exposure to light. The latent image is converted into a visible image by the action of a DEVELOPER.

Latitude. Tolerance of photographic material to variations in exposure.

Lens hood. Simple lens accessory, usually made of rubber or light metal, used to shield the lens from light coming from areas outside the field of view. Such light is the source of FLARE.

Lith film. Ultrahigh-contrast film used to eliminate grey tones and reduce the image to areas of pure black or pure white.

Long-focus lens. Lens of focal length greater than that of the STANDARD LENS for a given format. Long-focus lenses have a narrow field of view, and consequently make distant objects appear closer. See also TELEPHOTO LENS.

Low-key. Containing predominantly dark tones. See also HIGH KEY.

Macro lens. Strictly, a lens capable of giving a 1:1 magnification ratio (a life-size image); the term is generally used to describe any close-focusing lens. Macro lenses can also be used at ordinary subject distances.

Macrophotography. Close up photography in the range of magnification between life-size and about ten times life-size.

Magnification ratio. Ratio of image size to object size: The magnification ratio is sometimes useful in determining the correct exposure in close-up and macrophotography.

Mercury vapour lamp. Type of light source sometimes used in studio photography, giving a bluish light. The light is produced by passing an electric current through a tube filled with mercury vapour.

Microphotography. Technique used to copy documents and similar materials on to a very small-format film, so that a large amount of information may be stored compactly. The term is sometimes also used to refer to the technique of taking photographs through a microscope, otherwise known as PHOTOMICROGRAPHY.

Microprism. Special type of focusing screen composed of a grid of tiny prisms, often incorporated into the viewing screens of SLR cameras. The microprism gives a fragmented image

when the image is out of focus.

Mired. Acronym for Micro-Reciprocal Degree. Unit on a scale of COLOUR TEMPERATURE used to calibrate COLOUR CORRECTION FILTERS. The mired value of a light is given by the express. one million – colour temperature in Kelvins.

Mirror lens. Long-focus lens of extremely compact design whose construction is based on a combination of lenses and curved mirrors. Light rays from the subject are reflected backwards and forwards inside the barrel of the lens before reaching the film plane. Mirror lenses have a fixed aperture, typically $f8$ for a 500mm lens. Also known as a catadioptric lens. See also NEUTRAL DENSITY FILTERS.

Montage. Composite photographic image made from several different pictures by physically assembling them or printing them successively onto a single piece of paper.

Motor drive. Battery powered camera accessory, used to wind on the film automatically after each shot, capable of achieving several frames per second.

Negative. Image in which light tones are recorded as dark, and vice versa; in colour negatives every colour in the original subject is represented by its complementary colour.

Negative lens. See DIVERGING LENS.

Neutral density filter. Uniformly grey filter which reduces the brightness of an image without altering its colour content. Used in conjunction with lenses that have no diaphragm to control the aperture (such as MIRROR LENSES), or when the light is too bright for the speed of film used.

Newton's rings. Narrow multicoloured bands that appear when two transparent surfaces are sandwiched together with imperfect contact. The pattern is caused by interference, and can be troublesome when slides or negatives are held between glass or plastic.

Nodal point. Point of intersection between the optical axis of a compound lens and one of the two principal planes of refraction: a compound lens thus has a front and a rear nodal point, from which its basic measurements (such as focal length) are made.

Normal lens. See STANDARD LENS.

Opacity. Objective measurement of the degree of opaqueness of a material; the ratio of incident light to transmitted light.

Open flash. Technique of firing flash manually after the camera shutter has been opened instead of synchronizing the two.

Optical axis. Imaginary line through the optical centre of a lens system.

Orthochromatic. Term used to describe black and white emulsions that are insensitive to red light. See also PANCHROMATIC.

Oxidation. Chemical reaction in which a substance combines with oxygen. Developer tends to deteriorate as a result of oxidation unless stored in airtight containers.

Pan-and-tilt head. Type of tripod head employing independent locking mechanisms for movement in two planes at right angles to each other. Thus the camera can be locked in one plane while remaining free to move in the other.

Panchromatic. Term used to describe black and white photographic emulsions that are sensitive to all the visible colours (although not uniformly so). Most modern films are panchromatic. See also ORTHOCHROMATIC.

Panning. Technique of swinging the camera to follow a moving subject, used to convey the impression of speed. A relatively slow shutter speed is used, so that a sharp image of the moving object is recorded against a blurred background.

Panoramic camera. Special design of camera whose lens moves slowly through an arc during exposure, covering a long stretch of film.

Parallax. Apparent displacement of an object brought about by a change in viewpoint. Parallax error is apparent in close-ups only, shown in the discrepancy between the image produced by the lens and the view seen through the viewfinder in cameras where the viewfinder and taking lens are separate.

Pentaprism. Five-sided prism used in the construction of eye-level viewfinders for SLR cameras, providing a laterally correct, upright image. (In practice many pentaprisms have more than five sides, since unnecessary parts of the prism are cut off to reduce its bulk.)

pH value. Strictly, the logarithm of the concentration of hydrogen ions in grams per litre. Used as a scale of acidity or alkalinity of a substance. Water is neutral at pH 7.

Photo-electric cell. Light-sensitive cell used in the circuit of a light meter. Some types of photo-electric cell generate an electric current when stimulated by light; others react by a change in their electrical resistance.

Photoflood. Bright tungsten filament bulb used as an artificial light source in photography. The bulb is over-run and so has a short life.

Photogram. Photographic image produced by arranging objects on the surface of a sheet of photographic paper or film, or so that they cast a shadow directly onto the material as it is being exposed. The image is thus produced without the use of a lens.

Photometer. Instrument for measuring the intensity of light by comparing it with a standard source.

Photomicrography. Technique of taking photographs through the lens of a microscope, used to achieve magnifications greater than those obtainable using a MACRO LENS.

Physiogram. Photographic image of the pattern traced out by a light source suspended from a pendulum. The pattern depends on the arrangement and complexity of the pendulum.

Pinhole camera. Simple camera which employs a very small hole instead of a lens to form an image. Pinhole cameras are principally used as a simple demonstration of the idea that light travels in straight lines; but they can take photographs.

Polarizing filter. Thin transparent filter used as a lens accessory to cut down reflections from certain shiny surfaces (notably glass and water) or to intensify the colour of a blue sky. Polarizing filters are made of a material that will polarize light passing through it and which will also block a proportion of light that has already been polarized; rotating the filter will vary the proportion that is blocked.

Polarized light. Light whose electrical vibrations are confined to a single plane. In everyday conditions, light is usually unpolarized, having electrical (and magnetic) vibrations in every plane. Light reflected from shiny non-metallic surfaces which makes it difficult to distinguish colour and detail is frequently polarized and can be controlled with a POLARIZING FILTER.

Positive. Image in which the light tones correspond to the light areas of the subject, and the dark tones correspond to the dark areas; in a positive colour image, the colours of the subject are also represented by the same colours in the image. See NEGATIVE.

Positive lens. See CONVERGING LENS.

Posterization. Technique of drastically simplifying the tones of an image by making several negatives from an original, with different densities, contrasts, etc., and then sandwiching them together and printing them in register. The name comes from the bold, striking effects obtained in posters of the 1930s.

Primary colours. In the additive synthesis of colour, blue, green and red. Lights of these colours can be mixed together to give white light or light of any other colour.

Process film. Slow, fine-grained film of good resolving power, used for copying work.

Process lens. Highly corrected lens designed specially for copying work.

Pushing. Technique of extending the development of a film so as to increase its effective speed or to improve contrast. Usually used after rating a film at a higher than normal speed.

Rangefinder. Optical device for measuring distance, often coupled to the focusing mechanism of a camera lens. A rangefinder displays two images, showing the scene from slightly different viewpoints, which must be superimposed to establish the measurement of distance.

Real image. In optics, the term used to describe an image that can be formed on a screen, as distinct from a VIRTUAL IMAGE. The rays of light actually pass through the image before entering the eye of the observer.

Reciprocity law. Principle according to which the density of the image formed when an emulsion is developed is directly proportional to the duration of the exposure and the intensity of the light. However, with extremely short or long exposures and with unusual light intensities the reciprocity law fails to apply and unpredictable results occur. See also INTERMITTENCY EFFECT.

Reducer. Chemical agent used to reduce the density of a developed image either uniformly over the whole surface (leaving the contrast unaltered) or in proportion to the existing density (thus decreasing contrast).

Reflector. In photography, the sheets of white, grey or silverized card employed to reflect light into shadow areas, usually in studio lighting arrangements.

Reflex camera. Generic name for types of camera whose viewing systems employ a mirror to reflect an image onto a screen. See TWIN-LENS REFLEX CAMERA and SINGLE-LENS REFLEX CAMERA.

Refraction. Bending of a ray of light travelling obliquely from one medium to another; the ray is refracted at the surface of the two media. The angle through which a ray will be bent can be calculated from the refractive indices of the media.

Rehalogenization. The process of converting deposits of black metallic silver back into silver halides. This process may be used to bleach prints in preparation for toning. (See TONER).

Resin-coated (RC) paper.
Photographic printing paper coated with synthetic resin to prevent the paper base absorbing liquids during processing. Resin-coated papers can be washed and dried more quickly than untreated papers.

Resolving power. Ability of an optical system to distinguish between objects that are very close together; also used in photography to describe this ability in a film or paper emulsion.

Reticulation. Fine, irregular pattern appearing on the surface of an emulsion which has been subjected to a sudden and severe change in temperature or in the relative acidity/alkalinity of the processing solutions.

Retina. Light-sensitive layer at the back of the eye.

Reversal film. Photographic film which, when processed, gives a positive image; that is, intended for producing slides rather than negatives.

Reversing ring. Camera accessory which enables the lens to be attached back to front. Used in close-up photography to achieve higher image quality and greater magnification.

Ring flash. Type of electronic flash unit which fits around the lens to produce flat, shadowless lighting; particularly useful in close-up work.

Rising front. One of the principal CAMERA MOVEMENTS. The lens is moved vertically in a plane parallel to the film. Particularly important in architectural photography, where a rising front enables the photographer to

include the top of a tall building without distorting the vertical lines. See also CONVERGING VERTICALS.

Sabattier effect. Partial reversal of the tones of a photographic image resulting from a secondary exposure to light during development. Sometimes also known as SOLARIZATION or, more correctly, pseudo-solarization, it can be used to give special printing effects.

Safelight. Special darkroom lamp whose light is of a colour (such as red or orange) that will not affect certain photographic materials. Not all materials can be handled under a safelight, and some require a particular type of safelight designed specifically for them.

Saturated colour. Pure colour free from any admixture of grey.

Selenium cell. One of the principal types of photoelectric cell used in light meters. A selenium cell produces a current when stimulated by light, proportional to the intensity of the light.

Shading. Alternative term for DODGING.

Shutter. Camera mechanism which controls the duration of the exposure. The two principal types of shutter are BETWEEN-THE-LENS SHUTTERS and FOCAL-PLANE SHUTTERS.

Silver halide. Chemical compound of silver with a HALOGEN (for example, silver iodide, silver bromide or silver chloride). Silver bromide is the principal light-sensitive constituent of modern photographic emulsion, though other silver halides are also used.

Single-lens reflex (SLR) camera. One of the most popular types of camera design. Its name derives from its viewfinder system, which enables the user to see the image produced by the same lens that is used for taking the photograph. A hinged mirror reflects this image onto a viewing screen, where the picture may be composed and focused; when the shutter is released, the mirror flips out of the light path while the film is being exposed.

Slave unit. Photoelectric device used to trigger electronic flash units in studio work. The slave unit detects light from a primary flashgun linked directly to the camera, and fires the secondary flash unit to which it is connected.

SLR. Abbreviation of SINGLE-LENS REFLEX CAMERA.

Snoot. Conical lamp attachment used to control the beam of a studio light.

Soft focus. Slight diffusion of the image achieved by the use of a special filter or similar means, giving softening of the definition. Soft-focus effects are generally used to give a gentle, romantic haze to a photograph.

Solarization. Strictly, the complete or partial reversal of the tones of an image as a result of extreme overexposure.

Spectrum. The multicoloured band obtained when light is split up into its component WAVELENGTHS, as when a prism is used to split white light into coloured rays; the term may also refer to the complete range of electromagnetic radiation, extending from the shortest to the longest wavelengths and including visible light.

Speed. The sensitivity of an emulsion as measured on one of the various scales (see ASA, ISO and DIN); or the maximum aperture of which a given lens is capable.

Spherical aberration. Lens defect resulting in an unsharp image, caused by light rays passing through the outer edges of a lens being more strongly refracted than those passing through the central parts; not all rays, therefore, are brought to exactly the same focus.

Spot meter. Special type of light meter which takes a reading from a very narrow angle of view; in some TTL METERS the reading may be taken from only a small central portion of the image in the viewfinder.

Spotting. Retouching a print or negative to remove spots and blemishes.

Standard lens. Lens of focal length approximately equal to the diagonal of

the negative format for which it is intended. In the case of 35mm cameras the standard lens usually has a focal length in the range of 50-55mm, slightly greater than the actual diagonal of a full frame negative (about 43mm).

Stop. Alternative name for aperture setting or F-NUMBER.

Stop bath. Weak acidic solution used in processing as an intermediate bath between the DEVELOPER and the FIXER. The stop bath serves to halt the development completely, and at the same time to neutralize the alkaline developer, thereby preventing it lowering the acidity of the fixer when it is added.

Stopping down. Colloquial term for reducing the aperture of the lens. See also STOP.

Subminiature camera. Camera using 16mm film to take negatives measuring 12 × 17mm.

Subtractive colour printing. Principal method of filtration used in making prints from colour negatives. The colour balance of the print is established by exposing the paper through a suitable combination of yellow, magenta or cyan filters, which selectively block the part of the light giving rise to an unwanted colour CAST.

Supplementary lens. Simple POSITIVE LENS used as an accessory for close-ups. The supplementary lens fits over the normal lens, producing a slightly magnified image.

Telephoto lens. Strictly, a special type of LONG-FOCUS LENS, having an optical construction which consists of two lens groups, the front group acts as a converging sytem, while the rear group diverges the light rays. This construction results in the lens being physically shorter than its effective focal length. Most long-focus lenses are now of telephoto construction.

Test strip. Print showing the effects of several trial exposure times, made in order to establish the correct exposure for the final print.

TLR. Abbreviation of TWIN-LENS REFLEX CAMERA.

Tone separation. Technique similar to POSTERIZATION, used to strengthen the tonal range registered in a print by printing the highlights and the shadows separately.

Toner. Chemical used to alter the colour of a black and white print. There are four principal types of toner, each requiring a different process for treating the print. Almost any colour can be achieved.

Transparency. A photograph viewed by transmitted, rather than reflected, light. When mounted in a rigid frame, the transparency is called a slide.

T setting. Abbreviation of 'time' setting — a mark on some shutter controls. The T setting is used for long exposures when the photographer wishes to leave the camera with its shutter open. The first time the shutter release is pressed, the shutter opens; it remains open until the release is pressed a second time. See also B SETTING.

TTL meter. Through-the-lens meter. Built-in exposure meter which measures the intensity of light in the image produced by the main camera lens. Principally found in more sophisticated designs of SINGLE-LENS REFLEX CAMERAS.

Twin-lens reflex (TLR) camera. Type of camera whose viewing system employs a secondary lens of focal length equal to that of the main 'taking' lens: a fixed mirror reflects the image from the viewing lens up onto a ground-glass screen. Twin-lens reflex cameras suffer from PARALLAX error, particularly when focused at close distances, owing to the difference in position between the viewing lens and the taking lens. See also SINGLE-LENS REFLEX CAMERA.

Ultraviolet radiation. Electromagnetic radiation of wavelengths shorter than those of violet light, the shortest visible wavelength. They affect most photographic emulsions to some extent. See also INFRARED RADIATION.

UV filter. Filter used over the camera lens to absorb ULTRAVIOLET RADIATION, which is particularly prevalent on hazy days. A UV filter enables the photographer to penetrate the haze to some extent. UV filters, having no effect on the exposure, are sometimes kept permanently in position over the lens to protect it from damage.

View camera. Large-format studio camera whose viewing system consists of a ground-glass screen at the back of the camera on which the picture is composed and focused before the film is inserted. The front and back of the camera are attached by a flexible bellows unit, which allows a full range of CAMERA MOVEMENTS.

Viewfinder. Window or frame on a camera, showing the scene that will appear in the picture, and often incorporating a RANGEFINDER mechanism.

Vignette. Picture printed in such a way that the image fades gradually into the border area.

Virtual image. In optics, an image that cannot be obtained on a screen; a virtual image is seen in a position through which rays of light appear to have passed, but in fact have not. See also REAL IMAGE.

Wavelength. The distance between successive points of equal 'phase' on a wave; the distance, for example, between successive crests or successive troughs. The wavelength of a wave is inversely proportional to its frequency. The wavelength of visible light determines its colour.

Wetting agent. Chemical that has the effect of lowering the surface tension of water, often used in developers to prevent the formation of AIR BELLS, and in the final rinse (of film, in particular) to promote even drying.

Wide-angle lens. Lens of focal length shorter than that of a STANDARD LENS, and consequently having a wider ANGLE OF VIEW.

Working solution. Processing solution diluted to the strength at which it is intended to be used. Most chemicals are stored in a concentrated form, both to save space and to inhibit the deterioration of the chemical as a result of OXIDATION.

X-rays. Electromagnetic radiation with WAVELENGTHS very much shorter than those of visible light. X-rays are often used in security checks at airports and can, if sufficiently powerful, fog film.

Zone focusing. Technique of presetting the aperture and focusing of the camera so that the entire zone in which the subject is likely to appear is covered by the DEPTH OF FIELD. This technique is particularly useful in areas of photography such as sports or action photography in which there is not enough time to focus the camera more accurately at the moment of exposure.

Zone system. System of relating exposure readings to tonal values in picture-taking, development and printing, popularized by the photographer Ansel Adams.

Zoom lens. Lens of variable FOCAL LENGTH whose focusing remains unchanged while its focal length is being altered. Zooming is accomplished by changing the relative positions of some of the elements within the lens. Some zoom lenses have separate control rings for focusing and zooming, while on other designs a single ring serves for both purposes (twisting the ring focuses the lens, pushing or pulling it changes the focal length). The latter type is generally known as 'one-touch'. Various ranges of focal lengths are available in zoom lenses. Most typically, they extend from wide-angle to standard (say, 28-50mm); moderate wide-angle or standard to moderate telephoto (35-70mm or 50-135mm); or moderate to long telephoto (80-200mm). An extreme example is Nikon's 360-1200mm f11 zoom. The disadvantages of zooms are that they are heavier and have smaller maximum apertures than ordinary lenses.

NOTES

Film Type	Processing notes		Printing notes	
Date	Frames	Camera/Lens	Location/Subject	Exposure/Notes

Film Type		Processing notes		Printing notes
Date	Frames	Camera/Lens	Location/Subject	Exposure/Notes

Film Type		Processing notes		Printing notes
Date	Frames	Camera/Lens	Location/Subject	Exposure/Notes

Film Type		Processing notes		Printing notes
Date	Frames	Camera/ Lens	Location/Subject	Exposure/Notes

Film Type		Processing notes		Printing notes
Date	Frames	Camera/Lens	Location/Subject	Exposure/Notes

Film Type	Processing notes		Printing notes	
Date	Frames	Camera/Lens	Location/Subject	Exposure/Notes

Film Type	Processing notes		Printing notes	
Date	Frames	Camera/Lens	Location/Subject	Exposure/Notes

Film Type		Processing notes		Printing notes
Date	Frames	Camera/Lens	Location/Subject	Exposure/Notes

Film Type	Processing notes			Printing notes
Date	Frames	Camera/Lens	Location/Subject	Exposure/Notes

Film Type		Processing notes		Printing notes
Date	Frames	Camera/Lens	Location/Subject	Exposure/Notes

Film Type		Processing notes		Printing notes
Date	Frames	Camera/Lens	Location/Subject	Exposure/Notes

Film Type		Processing notes		Printing notes
Date	Frames	Camera/Lens	Location/Subject	Exposure/Notes

Film Type		Processing notes		Printing notes
Date	Frames	Camera/Lens	Location/Subject	Exposure/Notes

Film Type		Processing notes		Printing notes
Date	Frames	Camera/Lens	Location/Subject	Exposure/Notes

Film Type		Processing notes		Printing notes
Date	Frames	Camera/Lens.	Location/Subject	Exposure/Notes

Film Type	Processing notes		Printing notes	
Date	Frames	Camera/Lens	Location/Subject	Exposure/Notes

Film Type		Processing notes		Printing notes
Date	Frames	Camera/Lens	Location/Subject	Exposure/Notes

Film Type	Processing notes			Printing notes
Date	Frames	Camera/Lens	Location/Subject	Exposure/Notes

Film Type		Processing notes		Printing notes
Date	Frames	Camera/Lens	Location/Subject	Exposure/Notes

Film Type		Processing notes		Printing notes
Date	Frames	Camera/Lens	Location/Subject	Exposure/Notes

Film Type		Processing notes		Printing notes
Date	Frames	Camera/Lens	Location/Subject	Exposure/Notes

Film Type		Processing notes		Printing notes
Date	Frames	Camera/Lens	Location/Subject	Exposure/Notes

INDEX

Page numbers in **bold** type refer to main entries.